MANGA MONSTER MADNESS

David Okum

IMPACT

CINCINNATI, OHIO

www.impact-books.com

About the Author

David Okum has worked as a freelance artist and illustrator since 1984 and has had his manga work published since 1992, beginning with a story in a *Ninja High School* anthology published by Antarctic Press. He has since been included in two other Antarctic Press anthologies and several small-press comic books. His writing and artwork have appeared in six books by Guardians of Order. He is also the writer and artist of *Manga Madness* and *Superhero Madness* published by Impact Books (2004).

David studied fine art and history at the University of Waterloo in Ontario, Canada and works as a high school art teacher.

Acknowledgments

I'd like to thank the following people for their help and contributions: Jennifer, Stephanie and Caitlin Okum for keeping me focused on what was important with this book.

Mitch Krajewski, Stephen Markan, Rich Kinchlea, Dave Kinchlea and Nick Rintche for letting me bounce ideas (no matter how crazy) off them every week for the past twenty years or so.

Christine Mihaescu for her support and assistance, her help with the elves and all of the fantastic images and histories of castles she provided.

My editors at Impact, Pam Wissman and Gina Rath, and designer Wendy Dunning for helping make my work look good.

Dedication

To Hayao Miyazaki, Masamune Shirow and Yoshitaka Amano for sharing their personal visions and amazing talent with the world.

Library of Congress Cataloging in Publication Data
Okum, David
 Manga monster madness / David Okum.—1st ed.
 p. cm
 Includes index.
 ISBN 1-58180-606-X (pbk. : alk. paper)
 1. Monsters in art. 2. Comic books, strips, etc.—Japan—Technique. 3. Cartooning—Technique. I. Title.

NC1764.8.M65O58 2005
741.5—dc22 2004058110

Edited by Gina Rath
Production edited by Christina Xenos
Production art by Lisa Holstein
Designed by Wendy Dunning
Production coordinated by Mark Griffin

F+W PUBLICATIONS, INC.

Metric Conversion Chart

To convert	to	multiply by
Inches	Centimeters	2.54
Centimeters	Inches	0.4
Feet	Centimeters	30.5
Centimeters	Feet	0.03
Yards	Meters	0.9
Meters	Yards	1.1
Sq. Inches	Sq. Centimeters	6.45
Sq. Centimeters	Sq. Inches	0.16
Sq. Feet	Sq. Meters	0.09
Sq. Meters	Sq. Feet	10.8
Sq. Yards	Sq. Meters	0.8
Sq. Meters	Sq. Yards	1.2
Pounds	Kilograms	0.45
Kilograms	Pounds	2.2
Ounces	Grams	28.3
Grams	Ounces	0.035

Table of Contents

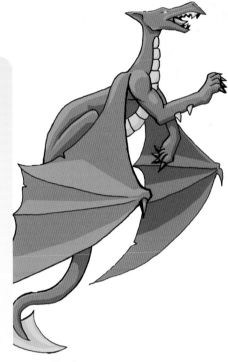

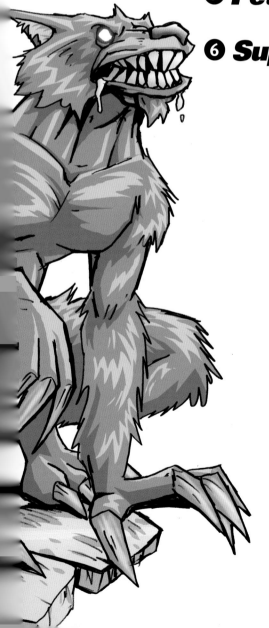

Introduction

Monsters have always been important in Japanese storytelling, often eclipsing the daring heroes with their outrageous antics and gruesome extremes.

Manga Monster Madness provides beginning artists with the basics for drawing the types of monsters that appear in Japanese comics (manga).

The book begins with an overview of basic techniques to help you master the unique style and substance of drawing manga monsters. Each of the following chapters focuses on one of the various genres of monsters: heroic fantasy (beasts and monsters), *daikaiju* (giant monsters), aliens, mutants, pet monsters and supernatural beings. Each genre has a unique style that needs to be explored individually.

Manga and anime are not genres; they are simply methods of presenting stories. Design elements are similar from manga to manga and anime to anime, but the personal stamp of each artist or design team adds character and individuality to each project.

Don't be afraid to let your personal style shine through the stylistic elements of manga. It would be a shame to allow your personal vision to vanish behind slavish copying of a favorite style or artist.

One important thing to remember about manga is that the presence of monsters in a story does not automatically make that manga a horror story. Within these pages you'll learn that manga monsters are so much more than snarling villains; they have personalities, motivations and goals.

Now let's bring on the monsters!

Before *you begin*

*T*here are some basic tools you will need to draw manga monsters:

- A clean, flat, well-lit drawing surface. A drawing table, desk, kitchen table or even a coffee table will do.
- Paper or board to draw on.
- A drawing medium.

Paper Depending on your needs you can draw on 2- to 4-ply bristol board sheets or sheets of bond printer paper. You can find reams (five-hundred sheets) of paper at any office supply store.

Different papers produce different results. Smooth paper has less chance of smudging your pencil lines or making an inked line crooked.

Coloring Colored pencils are easy to use, easy to find. They come in a variety of colors and shades. Colored markers can be difficult to master, but they produce very professional-looking results.

Painting your work can be painstaking and difficult, but the results are often very beautiful. Many shoujo (girl's comics) in Japan have wonderful covers painted using watercolors.

Using graphics software such as Adobe®Photoshop® to color has given artists access to a whole new world of professional effects and techniques.

Drawing Mediums

- ***Regular graphite pencils*** range from hard (H) to soft (B) varieties. Soft pencils (such as 2B or 4B) make strong, dark marks, but they are difficult to erase and tend to smudge easily. Hard pencils (such as 2H or 4H) make light, fine lines but can scratch into paper or board, leaving unwanted indentations that make inking and coloring difficult.

- ***Technical pencils*** make precise, consistent lines and allow for greater control and detail.

- ***A good pencil sharpener*** is handy for sharpening graphite pencils and colored pencils. Keep your pencils sharp for strong, crisp lines.

- ***Erasers*** clean up extra pencil lines on a finished drawing. White plastic erasers are preferred over pink erasers because they don't sand down the paper or smudge. Clean your plastic erasers by erasing on scrap paper until they look white again.

- ***Inking pens*** Inking is much more complicated than just tracing a pencil image. The wrong marker can ruin hours of hard work, so "test drive" all your pens until you are comfortable with the results. Use technical pens with permanent ink or a dip-type pen with India ink. You may also use India ink with a brush. Avoid using markers with water-based ink, which may fade or be damaged by moisture.

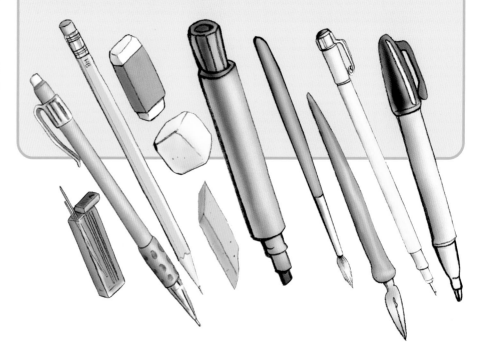

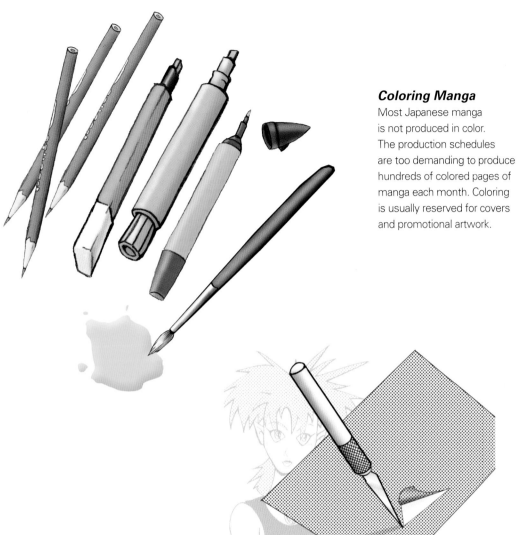

Coloring Manga

Most Japanese manga
is not produced in color.
The production schedules
are too demanding to produce
hundreds of colored pages of
manga each month. Coloring
is usually reserved for covers
and promotional artwork.

Screen Tone

Screen tone is the traditional
method used to shade manga.
These dry transfer sheets are
cut to the size and shape of
the desired area and transferred
neatly on top of inked artwork.

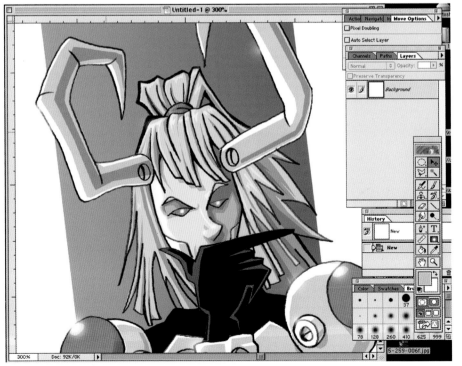

Computer Coloring

Computer coloring can be very flexible and
forgiving, and it allows the artist to preview
color combinations and effects that would be
too time consuming (or impossible) to do by
hand. The best computer coloring programs
allow you to use layers of color over color. This
allows smooth blending and coverage without
hiding the original artwork. Many professional
comic and manga artists use computer soft-
ware to color their artwork.

Ten drawing tips *and* tricks

1 **Block in your shapes and forms** with an HB or H pencil. Draw lightly to make extra lines easier to erase later.

2 **Rest your hand on a piece of** scrap paper as you draw to prevent smudging your artwork.

3 **Follow the steps in this book in order.** The first steps simplify the complex shapes. If you begin by drawing the last step you will have problems with proportion, anatomy, composition and 3-D form.

4 **Make sure all the ink is dry** before you start erasing the initial pencil lines or you'll have smudges.

5 **Vary the line thickness.** Lines that are all the same are boring and don't provide enough information about the form and mass of the object you are drawing. Thick lines will bring the drawing forward but can flatten the overall image. Lines that are too thin may not copy or scan properly.

6 **Use the best materials you can afford.** Acid-free waterproof and fadeproof pigment markers might seem expensive at first but are well worth the cost to prevent the heartbreak of your art fading or turning brown over time.

7 **Budget time to draw.** Give yourself an hour or two at a time to draw without distractions or interruptions. This usually requires more self-discipline than planning. Make sure you are not using this time surfing the Web, watching TV or gabbing on the phone.

8 **Don't hesitate to develop your own style.** Too many artists working in a manga style try to copy the style of their favorite manga artist. Everyone has an individual style to bring to their drawings, based on personal taste and technical ability. Don't pass up the opportunity to develop your own style.

9 **Surround yourself with fellow artists.** Join an online artist community (try a Web search). Nothing compares to showing your art to another artist for comments, criticism and support. You will find yourself wanting to do your best work and enjoying the social time with like-minded individuals.

10 **Be patient, practice and don't take constructive criticism personally.** Fill pages and pages of sketchbooks every day with studies of everything from cool shoes to architectural or anatomical details. Draw, draw, draw—even when you feel uninspired and unproductive.

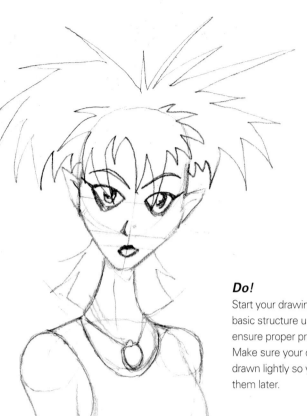

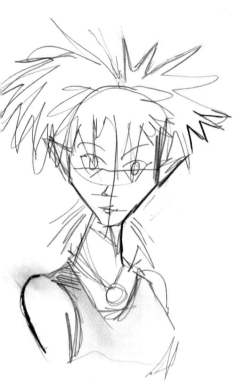

Do!

Start your drawings by blocking out the basic structure using construction lines to ensure proper proportion and 3-D form. Make sure your construction lines are drawn lightly so you can properly erase them later.

Don't!

Being careless or rushing your construction lines can create drawings with inaccurate proportions and sloppy details. Try to avoid smudging your work. The oils in your skin will mix with the pencil and bond to the paper, making it almost impossible to erase later on. If you really want to shade a drawing, use the tip of your pencil and build the value up carefully using finely crosshatched lines.

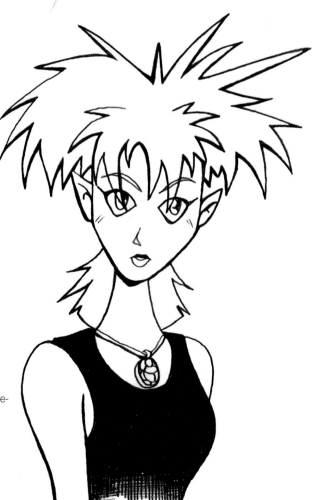

Do!

Vary the thickness and quality of your lines. Don't press down too hard with the pencil or you will polish the graphite and your image will get shiny. Build up areas of darkness with crosshatching. This level of detail could be done effectively with a technical pen or fine-tip marker.

shapes and 3-D Forms

To make forms look realistic, you should have an idea of how light falls on simple objects such as cylinders, cones, spheres and cubes. Try to give your shading a range of four to six levels (values) of gray, from lightest to darkest.

Try to maintain a consistent light direction in each of your drawings. Even though some situations may have multiple light sources, it is easier in the long run to have one main source of light in your drawing. This will make shading less confusing and make your drawings appear more realistic.

Highlights, the brightest areas of the drawing, show where light is falling on an object or character. Just leave the white of the paper for these highlights and draw around them; create a subtle range of value from lightest to darkest. Clean any extra lines or smudges with an eraser as needed.

Follow Forms

To make your object appear 3-D, follow the form of the object you are shading. Move the pencil or brush along the shape of the object as you drag it across the paper.

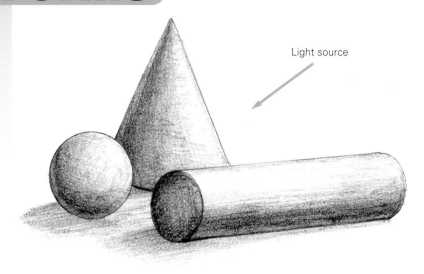

Light source

See the Light

- Practice shading simple forms.
- Keep the direction of your light consistent.
- There is gradual movement from light to dark on rounded objects.
- Notice the dramatic changes of light and dark on angular objects.

Light source

Halftones, or midtones, appear in the gradual transition (gradation) from light to dark.

The darkest areas occur where shadow is cast or describes form.

Highlights are the lightest areas that directly reflect light; leave them white or very light.

Rounded surfaces have gradual transitions from light to dark.

Shadows are cast on the figure from the head on the neck and the feet. Also note the shadow on the ground.

Shading Tips

Shading artwork is not that difficult if you make some basic decisions before you start. The first decision must be the location of your light source. This will help you realistically place shadows and plan details such as highlights and reflected light.

Consistency Is Important

Build up areas of shadow with fine, cross-hatched lines. Make sure the lines help to describe the form and are not flattening the overall image.

Keep the shadows and highlights consistent. The highlights in the eyes, for example, should appear to come from the same light source as on the belt or the toenails.

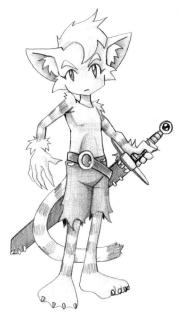

Pay Attention to Detail

Develop your shading from lightest to darkest. It is much easier to erase light lines than dark lines. Pay close attention to details such as the reflective nature of hair, the folds and creases of fabric and the subtle details on the skin's surface. Attention to all these details will help make your image a success.

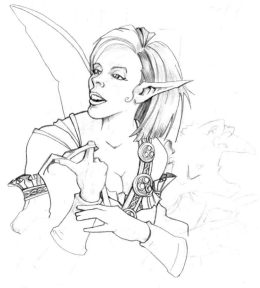

Shading Can Be Simplified

Shading can be simplified into areas of line. Notice how in this drawing the areas that have repeated parallel lines appear darker than areas without lines. The closer together the lines, the darker the area of shadow. Try to make the lines wrap around the form of the objects they are describing.

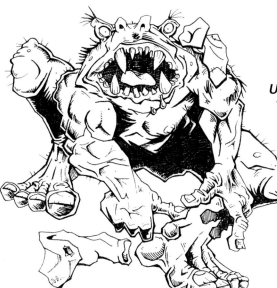

Use Line to Show Form

The principle of using line to shade works for pen-and-ink drawings as well. Use line wisely to show the 3-D forms of the object or figure you are drawing. Lines that are drawn randomly, or that go in only one direction, will appear to flatten the image and become more decorative than descriptive.

the *wonderful* World of Color

When white light reflects wavelengths off the objects that surround us, we perceive the changes in wavelength as color.

A color wheel is a helpful tool for organizing colors. The three primary (basic) colors are red, blue and yellow. They are considered primary because these three colors can be mixed to create every other color on the color wheel. Secondary colors are created when two primary colors are mixed together. Mixing yellow and red creates orange, mixing blue and red creates violet and mixing yellow and blue creates green. Tertiary colors are the six colors that are created when primary and secondary colors are combined. They are blue-green, blue-violet, red-violet, red-orange, yellow-orange and yellow-green.

Colors can also be divided into cool colors and warm colors. Cool colors include blue, green and violet, while warm colors include red, yellow and orange. Cool colors appear to recede and may not stand out in an image. Warm colors appear to come forward and can dominate a composition.

White and black do not appear on the color wheel. When white is added to a color it creates a tint of the color. When black is added to a color it creates a shade of that color.

Brown is created by mixing orange with a touch of blue. When all the colors are combined they create a neutral gray.

Color Harmonies

- **Complementary** A complementary scheme uses two colors opposite each other on the color wheel. When placed next to each other, one increases the brightness and intensity of the other color. For shading, instead of black, darken a color by using its complement, the color remains more vibrant.

- **Analogous** An analogous color scheme uses three colors that are located side by side on the color wheel. They work well together because they are similar to each other.

- **Monochromatic** The monochromatic color scheme is the easiest to understand. All you need is one color from the color wheel, white and black. Tint (add white) or shade (add black) the color to create areas of highlight and shadow.

- **Split Complementary** The split complementary color scheme is commonly used in design. One color acts as the accent or contrasting color and then you add two colors on either side of that color's complement. These three colors make up your color scheme.

- **Triadic** This scheme uses three colors evenly spaced on the color wheel. This allows for a wide range of color, but be careful: Only one color should dominate or the scheme will appear chaotic.

- **Every Crayon in the Box** This is a definite no-no. The image becomes difficult to view because no thought has gone into the way that different colors affect each other in the drawing.

- **Tetrad** This color scheme is when a square or rectangle is placed on a color wheel. The four colors touched by the four corners create an harmonious scheme with a variety of warm and cool colors. This creates a greater sense of colorful expression in the image. Try to make one or two colors more dominant in the composition and use the other colors to complement the main subject.

Warm Colors Cool Colors

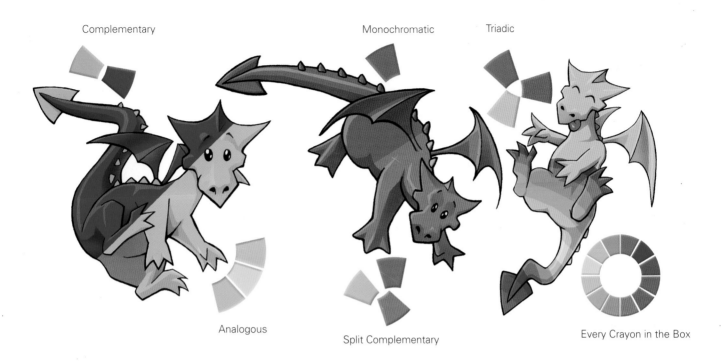

Complementary

Monochromatic

Triadic

Analogous

Split Complementary

Every Crayon in the Box

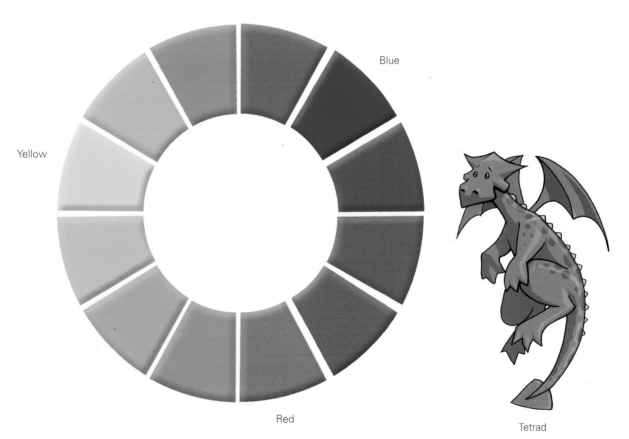

Blue

Yellow

Red

Tetrad

Colored Pencil
media techniques

Colored pencils are easily available and produce very professional results at a minimum of cost and hassle. With a little bit of practice you can create some amazing results without having your art appear to be a coloring contest entry.

Shade With a Complement

Use complements for shading or lessening the intensity of a color. Avoid shading with black, which can look dull and lifeless.

Try Color on Color

Use layers of similar colors for shading and blending. Use many versions of the same color to add depth and richness to the drawing. Change the pressure for dark and light areas. Blend colors evenly by layering color on color.

Lift and Highlight

Use an eraser or masking tape to lift color and create highlights and reflections. Erasers can create soft, blended areas of faded color. Try different types of erasers for different jobs.

Burnish to Hide Lines

Use a white colored pencil over an existing layer of color. The paper texture will be flattened out and a smooth, soft blending will appear. Burnishing the surface blends and lightens the colors below and hides unwanted hatching lines.

Rub for Texture

Rubbing over existing surfaces can produce interesting textures. Place the paper over the surface and rub with the side of a colored pencil to transfer lettering, shapes and realistic textures.

Cover for Definition

Save defined edges by covering areas of the drawing with masking tape or pieces of paper. This technique is very effective for highlights.

Create Visual Excitement

Tinted paper allows you to develop 3-D images using light colors. This technique can be a challenge at first as it is the opposite of shading on white paper, but the results can be visually exciting.

Imitate Cell Shading

Colored pencils can imitate the coloring techniques found in manga and anime. Using a consistent pressure, it is possible to create very solid areas of color. Use a darker value of the color or its complement to indicate areas of shadow. Traditional animation shading is not smooth but uses sharp edges and blocks of color. This "cell shading" is often desired when the artist is attempting to make the image appear as if it were taken from an animated film.

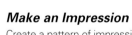

Make an Impression

Create a pattern of impressions on the surface of the paper. You can create impressions in the paper using the back of a pencil, your fingernail, the point of a dried-up ballpoint pen or any dull, pointed object. After creating a pattern, lightly shade over the area with a colored pencil. White lines will then appear where the impressions were made.

Colored Pencil Dos

- Colored pencil can develop a waxy or powdery buildup. Prevent smearing your art by resting your hand on a piece of scrap paper.

- Be careful when you are adding color. You want to stay in the lines and make sure you are creating 3-D effects with consistent shading and highlights.

- Keep colored pencils sharp; you can damage the paper with a dull pencil and it is easier to create a solid color, not one that fades in and out from light to dark.

- Ghost lines appear when you inadvertently scratch or impress your paper. You can make these lines disappear by cranking down on the coloring or burnishing and blending with a white colored pencil.

Human anatomical proportions

Although drawings of monsters don't have to follow any particular anatomy rules, it's always a good idea to know the rules before you break them.

"Classic" human proportions are surprisingly consistent. Half the figure should be made up of legs and feet. These proportions vary, depending on the age of the character and the level of simplification and stylization of the character.

Super-Deformed

Proportions of super-deformed characters are 2 to 3 heads tall (see page 23).

Adults
- Adult human "classic" proportions range from 8 to 8½ heads tall.
- The neck is about ¼ of the head's height.
- Shoulder width is roughly the height of two heads.
- Wrists begin at the halfway mark of the figure.

Teens
- Teens and the average-size human range from 7 to 7½ heads tall.
- Teen shoulders are often narrower and rounder than adult shoulders.

Children
- Older children range from 4½ to 5 heads tall.
- Children's hands and feet seem larger because the rest of the body is less developed.

Toddlers or Chibis
- Toddler or chibi proportions are often 3 to 3½ heads tall.
- The head appears much larger in relation to the rest of the body.
- Keep the eyes large and expressive.

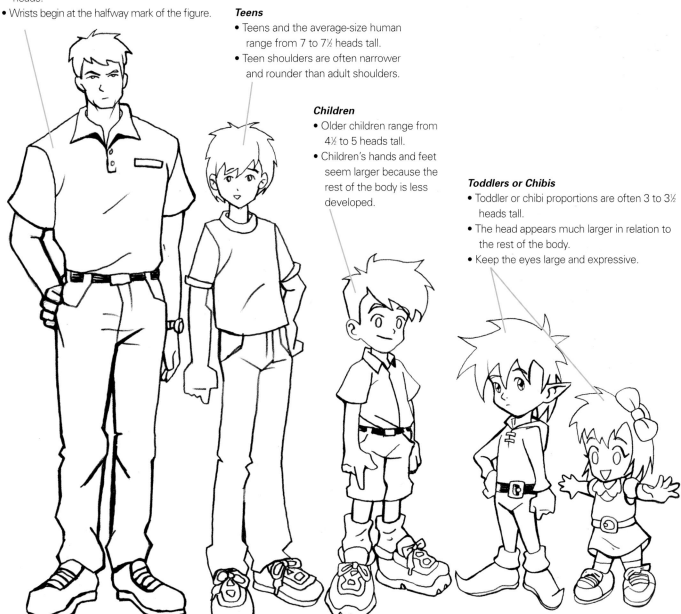

Anatomy *of* bipeds

Bipedal monsters are the closest to humans because they walk and run on two legs, just like us, but the types of legs may vary greatly.

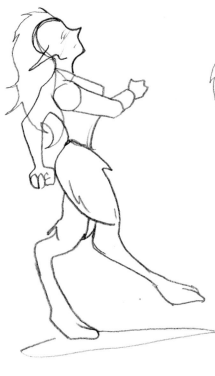

Animal vs. Human Legs

Some monsters, like fauns and werewolves, have animal-like or digitigrade rear legs. This technically means that the weight of the figure is placed on the balls of the feet and the ankle acts as a reverse knee. This can present some unique anatomical problems to solve, because the character will move and act differently from a humanoid biped.

Line Up the Head

The head should line up with the distribution of weight for the figure. This character's weight is spread between the legs, with more weight placed upon his right leg. Notice how his knees are bent and his left heel is just lifting off the ground.

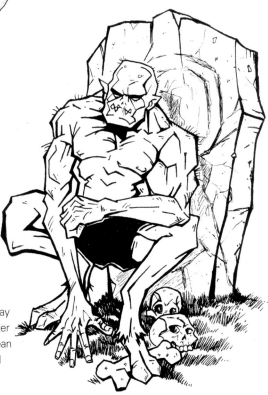

Digitigrade Feet

The feet of digitigrade characters may appear toe- or hoof-like. The character may need to balance with a tail or lean forward and use its hands to spread the weight more efficiently.

The Nature of the Monster

Tails provide a reasonable counterbalance. Other animal-like details may also be added depending on the nature of the monster. This werewolf has a tail, claws, fur and a wolf-like jaw filled with razor-sharp teeth.

Anatomy of quadrupeds

Designed for four-legged movement, quadrupeds are usually larger and faster than bipeds.

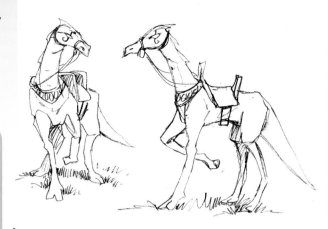

Alternate Beasts of Burden

Fantasy or alien worlds can produce alternate beasts of burden. This quadruped appears to be part lizard or dragon. There is a saddle and reins but no stirrups for the feet, meaning that this is probably not a beast that is used as a warhorse.

Helpful Stirrups

Stirrups were added to saddles to help riders maintain a steady posture on the horse. Stirrups existed over 1,700 years ago in China and over 2,000 years ago in Mongolia, but were not common in Europe until after the eighth century. After stirrups were invented, warriors could ride wearing armor and fight from their horses; they did not even need to dismount to do battle. Stirrups are also helpful for accurate archery and throwing from horseback.

Horse and Warrior as One

A charging warhorse seems to fly across the battlefield. A horse in full gallop shifts its weight to the front and uses its rear legs to propel itself. The rider must lean forward to compensate, actively driving the horse forward with kicks and maintaining a tight rein so the horse does not falter. Horse and warrior become one weapon.

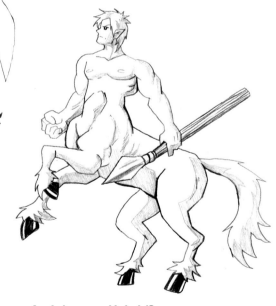

The Gallop of a Canine

Different quadrupeds move in different ways. Canines gallop as well, using their forelegs to pull themselves onward and their hind legs to spring ahead.

An Inhuman Hybrid?

Classic stories of centaurs in ancient Greece probably related to a time when the forefathers of the Greeks battled mounted warriors from the East. Fighting on horseback was so foreign to the ancient Greeks that the invaders were probably thought to be some sort of inhuman hybrid of man and beast.

Wings and things

Wings are often found on monsters in manga and anime, whether on a graceful tenshi (angel) or a powerful tatsu (dragon).

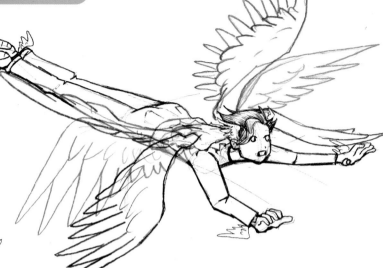

Small Wings

Similar to sails on a ship, wings rise and billow, trapping air and producing lift and movement. The small wings on the wrists, ankles and temples of this tenshi might help add maneuverability for sudden changes in direction and speed.

Unexpected Wings

Not all wings have to be realistic in manga. This fighting monster's ears make excellent wings in a pinch. Whimsy and the unexpected are all part of the appeal of manga monsters.

Wing Structures

The structures of the bird wing and the bat wing are radically different. Rigid wings such as the feathered wing of a bird (a) are efficient for creating lift and speed. The leathery, flexible, bat-like wing of the dragon (b) allows for greater maneuverability and quick changes in direction.

a

b

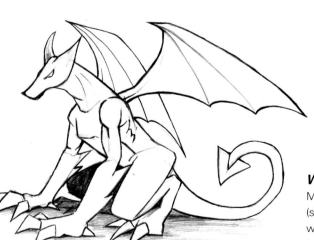

Wing Placement

Make sure the wings are placed on or just above the scapulas (shoulder blades), just behind the shoulders. Operational wings would require a large keel-like sternum (breast bone) reaching out two feet for a human-sized flyer to allow for the muscle necessary to take wing. Fantasy takes liberties with anatomy.

Fur, Claws, tails and fangs

Manga monsters may be covered in everything from skin to scales or fur to foam. They are armed with a dazzling array of natural weapons and can often produce attacks of super-natural origin.

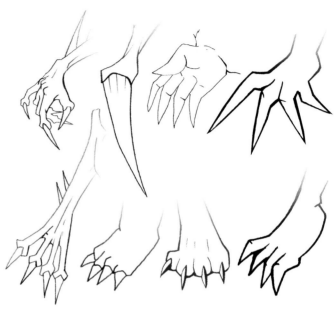

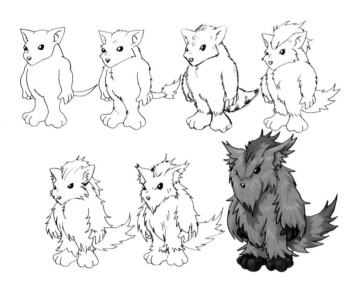

Claws, Fingers and Toes Vary

Claws come in many shapes and sizes. The number of fingers or toes can vary as well. Humanoid creatures are often depicted with four fingers and an opposable thumb. Animal-like creatures often have three fingers and a thumb or no thumb at all. Truly alien beings may have only one cruel claw.

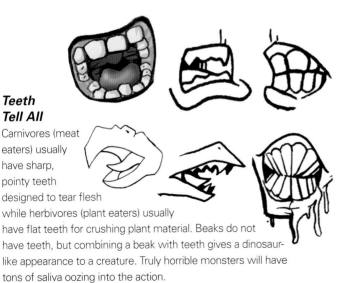

Fur Changes Appearance

The growth patterns of fur can radically change the appearance of a beast. Here the shorthaired version of the monster seems like a totally different being than the longhaired creature. Other issues such as fur color, pattern and placement add to the individual appearance of the monster.

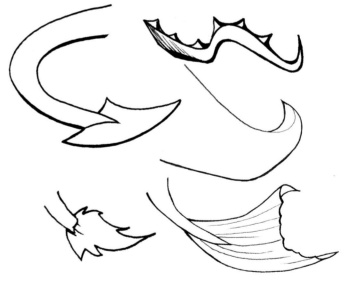

Teeth Tell All

Carnivores (meat eaters) usually have sharp, pointy teeth designed to tear flesh while herbivores (plant eaters) usually have flat teeth for crushing plant material. Beaks do not have teeth, but combining a beak with teeth gives a dinosaur-like appearance to a creature. Truly horrible monsters will have tons of saliva oozing into the action.

The Tail Reflects the Creature

Tails are generally used as a counterbalance but, as in the example of the fish, can be used for movement. The tail should reflect the individual nature of the creature it is attached to. An arrow-point tail is often associated with devils and demons, while a spiny tail is usually associated with lizards and dinosaurs.

anatomy in *Action*

*I*t's pretty boring just having page after page of monsters standing around looking tough. Eventually, you will have to show them doing something. It's a good idea to be able to draw monsters in a variety of action poses: running, jumping, attacking or defending. Keep a file of action poses that you can reference when needed, or have a friend strike action poses from time to time. You might even want to invest in an action figure or two to get a portable, poseable model to draw from.

A Monster in Action

When showing a monster in action it is a good idea to show either the beginning of the action or the end of the action. Break the action down into basic poses and then decide which pose best describes the action you are trying to depict.

The crouching pose on the far right is a good start but might not be identified as a jump. The middle stage of the jump is too neutral and not totally recognizable. The final airborne leap would probably be the best of the three poses because it shows the most action and dynamic movement.

Running Bipeds

Running creatures may have different ways of moving their bodies depending on how they are designed. As they run, bipeds usually use their arms to center their balance of mass, add lift for forward momentum and add upper-body strength to the strides of a sprint.

super-deformed Monsters

Super-deformed (SD) creatures do not have to follow the rules of physics like beings in the real world.

Simplified Anatomy

Sometimes the anatomy in manga and anime can be totally simplified into flat shapes. Characters such as Sanrio's Hello Kitty or Sega's Sonic the Hedgehog fall into this incredibly stylized form of SD characters.

Compare

The difference in size between the chibi (3 to 3½ heads) and the SD (2 to 3 heads) is obvious in this illustration. The eyes are much larger and expressive on the SD head and the face and figure have less detail. Avoid any muscle definition or realistic anatomy.

Over-the-Top Expressions

SD expressions are totally over the top. The sweat drop often represents embarrassment or frustration. Mouths and eyes can be as big and expressive as you like. Details such as noses and lips are usually ignored unless they are essential for the character. Keep things loose and fun!

Exaggerated and Expressive

SD anatomy is exaggerated and expressive, not realistic. The feet are often overly large and the poses are innocent and childlike.

monsters *in* Manga

Monsters play a crucial role in the folklore and imagination of the people of Japan. In traditional Shinto belief, everything has a supernatural element, or kami. Every rock, tree, person, animal, river, mountain, idea or feeling has a kami. Kami are spirits, not necessarily gods, that are associated with everyday things. The spirits of the dead are also considered kami, which may be the origin of the belief in ancestor worship.

Respect for all things seems only logical when you believe that all things have a spirit. This respect is often illustrated as environmentalism in manga and anime. Monsters often originate when nature is tampered with or traditions are overlooked. Godzilla, for example, was created from a nuclear test. Ghosts of ancestors return when they have been disrespected or ignored.

Western culture has its share of monster stories, and the monster is usually depicted as the "bad guy." In contrast, many monster stories from Japan depict the monster as the "hero" of the story. Even Godzilla defends the Earth from alien invasion from time to time. Powerful heroes who also possess supernatural origins or abilities often confront manga monsters. Monsters appear in Japanese culture not only as horrifying bogeymen, but as cultural touchstones and a warning to maintain respect for tradition and natural balance.

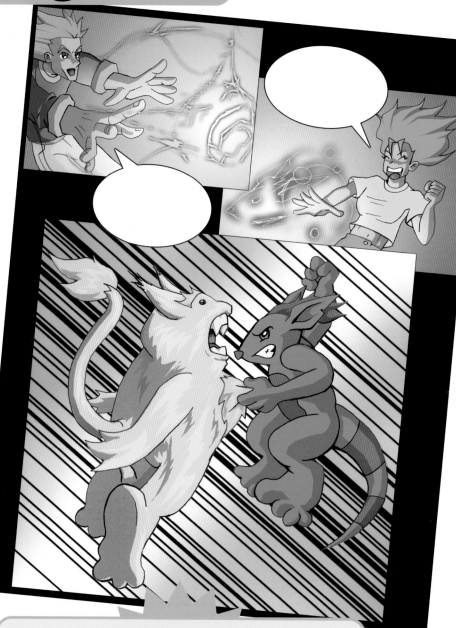

Traditional Manga

Japanese tradition classifies monsters into four basic types: Obake/Bakemono, Oni, Yokai and Yurei.

- **Obake/Bakemono** means "transforming thing" but can also refer to strange or bizarre creatures.
- **Oni** are demons or ogres armed with fangs and horns.
- **Yokai** are a wide variety of beasts such as goblins and ghouls.
- **Yurei** are classic ghosts, usually seeking revenge for a wrongful death.

heroic fantasy beasts
and Monsters and Daikaiju

The heroic fantasy genre has become more and more popular in recent anime and manga thanks largely to the popularity of role-playing video games set in medieval-fantasy settings.

Elements of legends, fairy tales and mythology are often combined with the modern world, creating a clash of reality and fantasy.

The Japanese word daikaiju essentially means "giant monster." Daikaiju manga are often based on films or television shows with giant monsters—and property damage on a massive scale.

Daikaiju are often out-of-control beasts that seem to instinctively home in on major cities or oil refineries in a spree of fiery destruction.

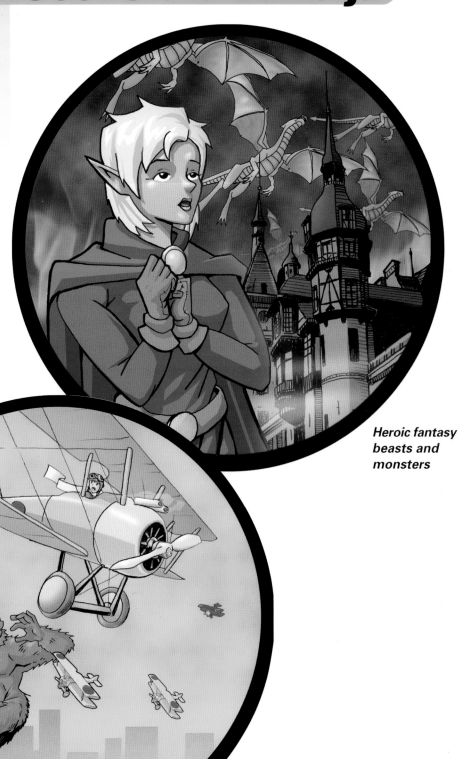

Heroic fantasy beasts and monsters

Daikaiju

aliens *and*
Mutants

Alien monsters and cultures are classic elements in science fiction. Manga aliens often provide a powerful invading force from which the Earth must defend itself. The alien invasion may appear as a dramatic fleet of war-ships, or the invasion may have already happened in secret. The heroes fight to defend something, only to discover that they actually have been aiding the enemy who was hiding behind a familiar façade.

Often set against a bleak, futuristic background, manga has dealt in many creative ways with the question of what it means to be human. The next stage in human evolution could involve devel-opment of supreme mental abilities, or it might even turn us into an entirely new species. Mutants include animal hybrids and cybernetic warriors.

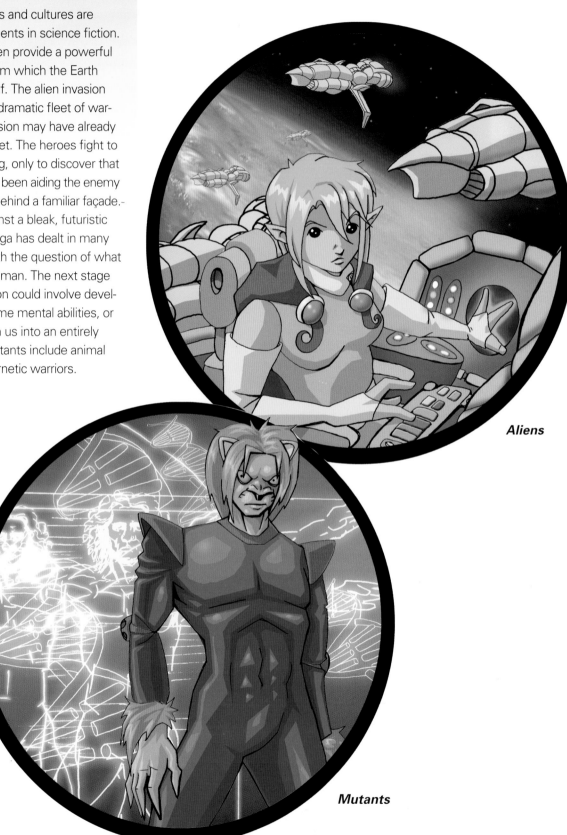

Aliens

Mutants

Pet Monsters *and* supernatural beings

O ne of the most popular anime and manga genres in recent years features pet monsters. The connection between children and the monsters that fight to defend them is a deep, often spiritual bond. The heroes must learn that if pet monsters are treated with respect and honor, they will share some of their awesome power with their human "masters."

The supernatural genre assumes that dark things are lurking in the background shadows of our comfortable reality. The things that go bump in the night become real, continuing an ancient battle that transcends good and evil. What is supernatural and what is human? Manga is not afraid to explore the dark side; many of its protagonists are the same monsters that most Westerners fear.

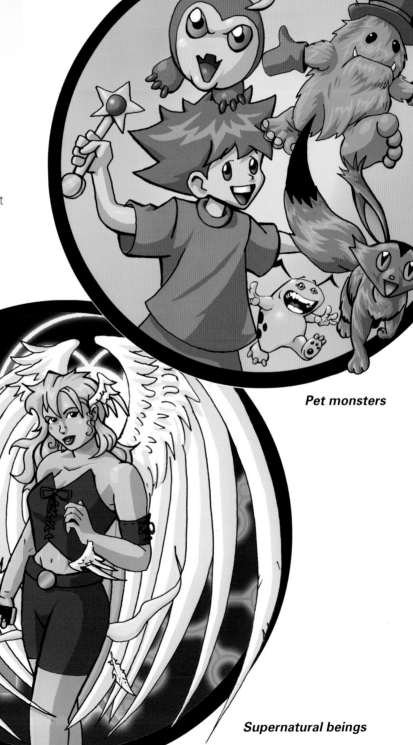

Pet monsters

Supernatural beings

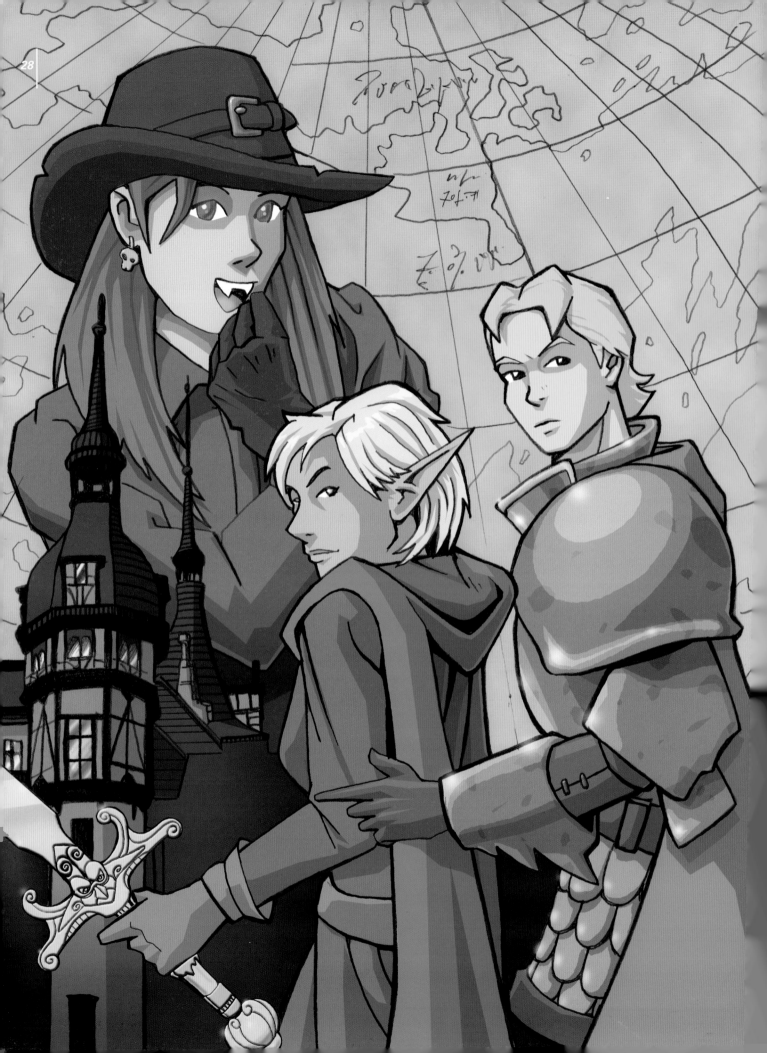

heroic
FANTASY

Heroic fantasy stories have always been part of Japanese folklore. The exploits of clever heroes and dashing samurai are common themes of novels, plays and manga. For more exotic fantasy, Japanese writers often look to Chinese myth and legend for inspiration. Recently, with the development of several incredibly successful fantasy role-playing video games (starting with *Dragon Quest* and moving through to the *Square Enix Final Fantasy* series), there has been a renewed interest in "Western" fantasy inspired more by European than Asian legend.

The heroic fantasy genre is characterized by a young hero, who has an unusual or tragic past, embarking on a quest to defeat a villain who is often the shadow side of the hero. The hero must rise above the temptation to turn into what he is fighting against. The hero must overcome a series of obstacles and is usually aided by a group of sidekicks and guides. The hero is often unable to achieve the quest alone and often requires help from the group to succeed.

Dragon

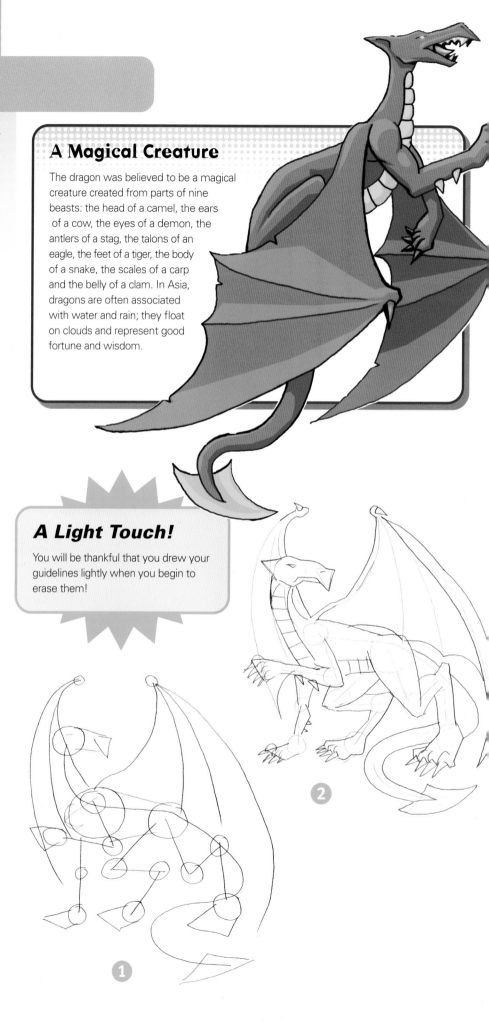

The dragon is a classic heroic fantasy monster. Symbolically, it represents evil, greed and the ultimate challenge, but as one looks deeper into myth and legend the dragon becomes something more complex.

The dragon in this demo is a typical "Western" fire-breathing dragon: covered in scales, with bat wings, and defending some forgotten treasure. Dragons are often found sleeping underground, but when awakened, they become instruments of death and destruction.

1 Start simply with sticks, ovals and circles to create the basic structure of the dragon. The rules of humanoid anatomy do not need to be followed, but logically the weight should rest on the right front leg as the dragon turns to look at something. Planning out the structure at this stage makes it easier to be consistent with anatomy later on in the drawing.

2 Start fleshing out the figure, adding details such as claws, spikes and a pointed tail. Draw very lightly with your pencil until you finish all the details. A ridge of thick scales runs down the belly of the dragon. The bat-like wings should have fingers that are attached by membranes of skin. Notice how the wings rise out of the back just behind the shoulders (not out of the neck or ribcage).

A Magical Creature

The dragon was believed to be a magical creature created from parts of nine beasts: the head of a camel, the ears of a cow, the eyes of a demon, the antlers of a stag, the talons of an eagle, the feet of a tiger, the body of a snake, the scales of a carp and the belly of a clam. In Asia, dragons are often associated with water and rain; they float on clouds and represent good fortune and wisdom.

A Light Touch!

You will be thankful that you drew your guidelines lightly when you begin to erase them!

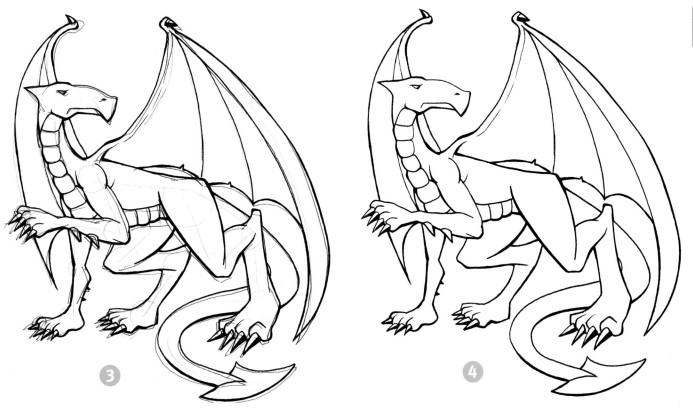

3 Finish the anatomical details by carefully drawing over the pencil roughs with ink. Some areas such as the wings, tail and claws require more cleaning up at this stage.

4 Use your eraser to carefully remove the original pencil lines. Make sure the ink has completely dried or you will have a nasty smudging situation. If you are using pencil at this stage instead of ink, be careful that you don't erase your final lines.

5 Once you decide on the location of your light source, be sure all the coloring and shading of the figure consistently shows highlights on the light side and shadows on the dark side. Use a white colored pencil to lighten the highlights and a green colored pencil to darken the shadows. The complementary colors red and green will create a neutral dark area where they are blended together. To achieve a gold effect on the belly scales, use white for the highlights and orange for the reflections and shadows. Darken the orange with brown.

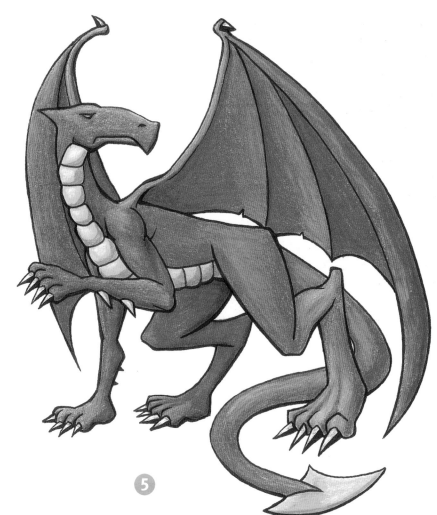

Griffon

The griffon is a strange monster combining the body of a lion with the head and wings (and sometimes talons) of a giant eagle. Griffons were thought to be excellent guards with keen eyesight and powerful claws. Some griffons had scorpion-like tails that injected powerful venom into their victims.

In medieval heraldry, the griffon represented valor, bravery and alertness.

1 Block in the basic structure using lines and ovals. Make the pose confident and vigilant. This is a fairly complex creature, with many anatomical features that need to somehow work together visually. The wings shouldn't appear too small or too large for the size of the beast.

2 Lightly block in over the rough structure the details of the head, wings and claws. It isn't necessary to draw every feather on the wings. You can suggest a few feathers now and a few more later when you color and shade the image.

Use Reference Photos

Look at reference photos of lions and eagles to draw convincing anatomy. Even though the image is a stylized cartoon image of a fantasy monster, the basic details of feather growth patterns on the wings and basic anatomy should be carefully observed.

Combination Beasties

Griffons appear in the legends and art of ancient Persia, Assyria and Babylonia. They represent the common trick in mythology of combining two unrelated creatures. Variations of this theme are Pegasus (horse and bird), the hippogriff (horse and eagle) and the manticore (lion body, human head and scorpion tail).

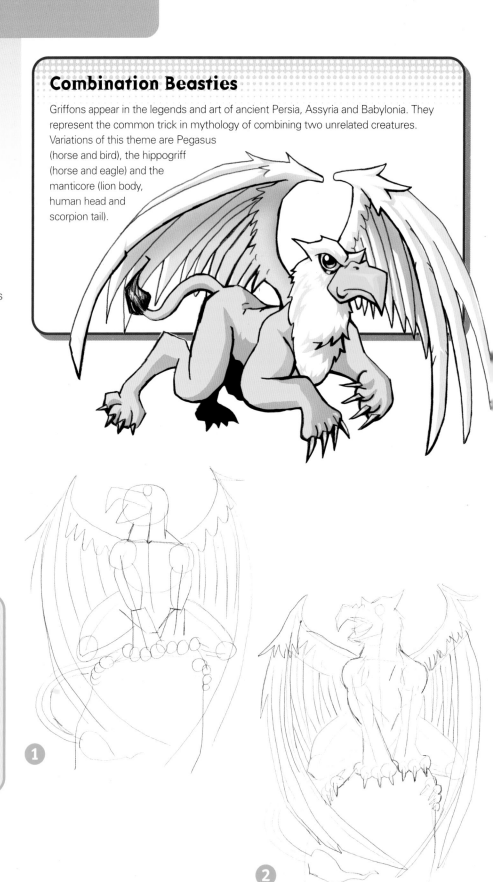

1

2

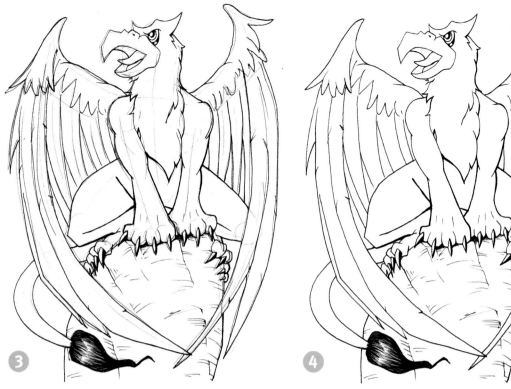

3 Clean up the rough pencil lines with ink. Details on the feathers and highlights on the tail help make the image more convincing. The eyes should look piercing and wise.

4 Take care erasing the rough pencil lines. You may need to darken some lines and vary the thickness as you go. Keep your shading consistent. The highlights on the eyes should relate to the highlights on the claws and the hair on the end of the tail.

5 The feathers of the wings are very complex. Keep your shading consistent with that of step 4; changing the direction of the shading at this stage would ruin all of your hard work.

Remember to keep things simple by suggesting detail rather than drawing every particular. Manga artists use shortcuts whenever they can because of the sheer volume of work and the frequent deadlines involved.

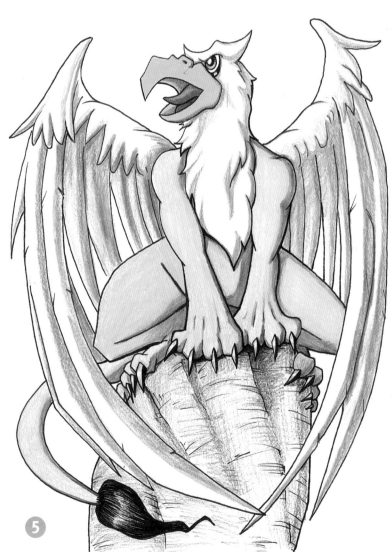

Elf

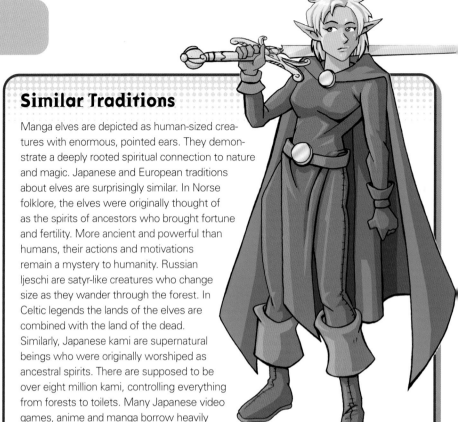

Elves in manga and anime are usually depicted with enormous ears. Like the huge eyes often seen in manga and anime, large ears are an artistic convention that quickly distinguishes elves from human heroes, providing greater expression of personality and character.

Although based on traditional European legends of fairy folk, elves in manga:

- are often depicted as spiritually and magically superior to human beings.
- can be powerful forces of good or malevolent tricksters who lure the unwary to danger and devise elaborate pranks with potentially deadly results.
- are rarely the main characters; they are usually depicted as guides or magicians.
- may provide comic relief with their unusual behavior and inhuman temperaments.
- have become fan favorites, providing some amazing inspiration for costumes at conventions and in fan art.

When drawing the elf, keep the form fluid and graceful. The strength and agility of the elf should be obvious when she holds her massive sword in one hand and leaps out from the bushes. Make her hair and cape billow out behind her to reveal her direction of movement.

1 Block in the details of the figure, focusing on anatomical consistency. Some clothing and weapon information can be included at this point.

2 Continue to develop features such as the face, hair and clothing. Keep the figure 3-D; the cape should ripple, not just lie flat against her back. Draw all these things as basic shapes and forms.

Similar Traditions

Manga elves are depicted as human-sized creatures with enormous, pointed ears. They demonstrate a deeply rooted spiritual connection to nature and magic. Japanese and European traditions about elves are surprisingly similar. In Norse folklore, the elves were originally thought of as the spirits of ancestors who brought fortune and fertility. More ancient and powerful than humans, their actions and motivations remain a mystery to humanity. Russian ljeschi are satyr-like creatures who change size as they wander through the forest. In Celtic legends the lands of the elves are combined with the land of the dead. Similarly, Japanese kami are supernatural beings who were originally worshiped as ancestral spirits. There are supposed to be over eight million kami, controlling everything from forests to toilets. Many Japanese video games, anime and manga borrow heavily from Western legends and depict traditional European elves.

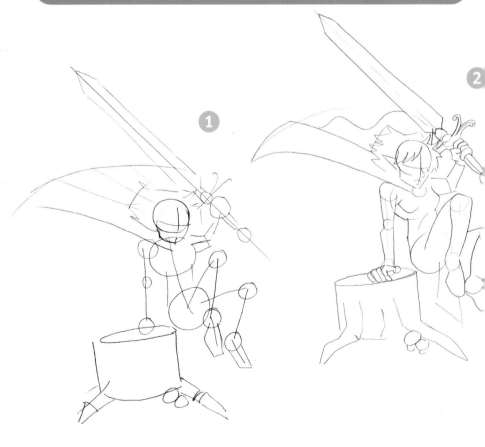

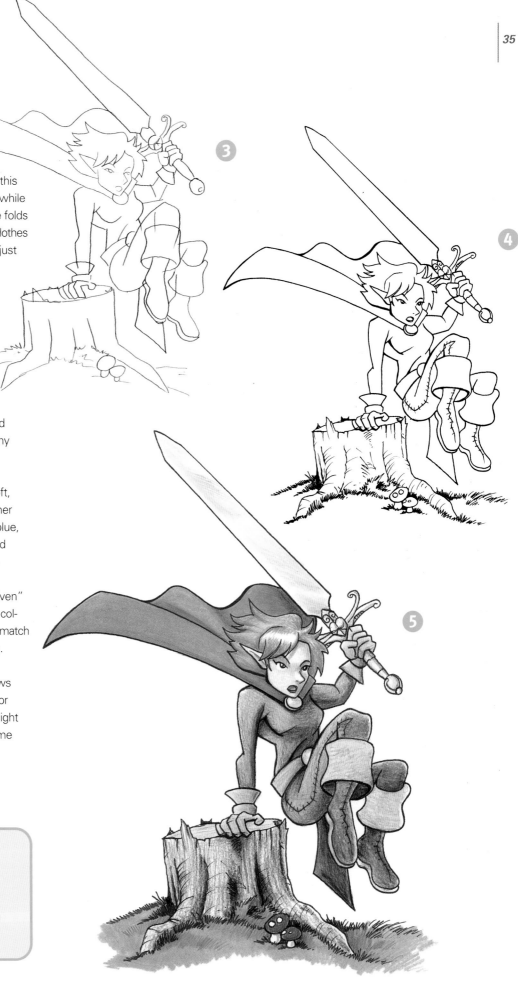

3 Erase extra construction lines at this point so you don't get confused while adding the details. Pay attention to the folds and wrinkles of the clothing. Make the clothes appear to wrap around the figure, not just lie flat against the body.

4 Vary the thickness and weight of the lines. Use thick, dark lines for areas of weight and shadow and for areas of shading or folds.

At this point, this drawing should be able to stand on its own although it lacks important shading and color information. Carefully clean up any extra pencil lines.

5 The elf's clothing is colored in soft, natural earth tones, connecting her to nature. Her hair is an otherworldly blue, symbolic of spiritual power, energy and coolheadedness. As you shade, try to keep the forms rounded and 3-D.

Try mixing up new and exciting "elven" colors that you can't get in a standard colored pencil box. Blend, erase, mix and match to create something new and exciting.

A strong sense of light and dark is important to create convincing shadows and highlights. Look at some models or photo references to understand how light falls across the figure, highlighting some areas and casting others in shadow.

Create an Environment

Adding a tree stump and toadstools gives a sense of place, incorporating the elf into the environment.

Ogre

Ogres are large, thick-headed giants who plunder the countryside and terrorize the innocent. They are known for both their cruelty and stupidity. And they often gather fortunes of treasure and shiny trinkets. Ogres are tough adversaries, often able to hold off large groups of well-armed warriors single-handedly.

1 Block in the structure of the figure. Sketch in his club as a cylinder. Getting a sense of the 3-D forms at this stage really helps later on when you are drawing the details.

2 Make him big and muscular. The hands and feet have three fingers and a thumb or big toe (this makes the ogre seem less human). Indicate the positioning of his right arm at this stage even though it is overlapped by his right leg and will eventually be hidden. Drawing in the hidden details strengthens the image and maintains correct proportion and anatomy.

3 Details such as the hair, tusks, sideburns and eyebrows help to establish character and cultural information. The pose is active and dynamic for such a bulky monster.

Oni

Many Japanese legends use the term oni for ogres. In Japanese Buddhism, oni have come to be known as demons that live in hell (see page 112), but many oni existed in stories long before Buddhism entered Japan in the sixth century. The oldest example of oni in Japanese myth is a horrible giant with one eye and one foot. It is often seen wrapped in animal skins and has a savage, fearsome appearance. The oni are symbols of cruelty and evil.

The concept of oni is found in everyday Japanese traditions. When someone is "it" in hide-and-seek, that person is called "oni." If someone is described as an oni it means that that person is cruel and heartless. During eras when the Japanese lived in a self-imposed seclusion from the rest of the world, they considered foreigners as oni.

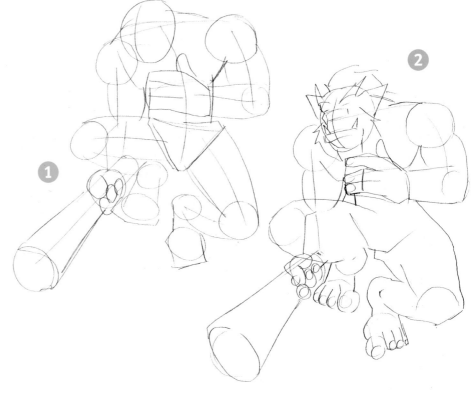

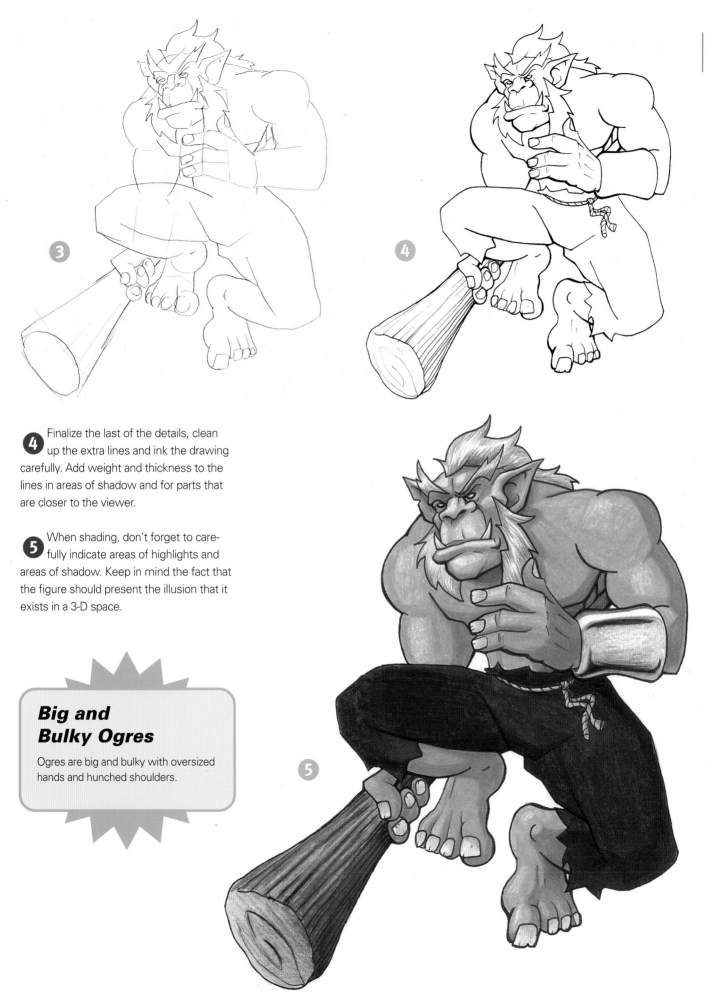

4 Finalize the last of the details, clean up the extra lines and ink the drawing carefully. Add weight and thickness to the lines in areas of shadow and for parts that are closer to the viewer.

5 When shading, don't forget to carefully indicate areas of highlights and areas of shadow. Keep in mind the fact that the figure should present the illusion that it exists in a 3-D space.

Big and Bulky Ogres

Ogres are big and bulky with oversized hands and hunched shoulders.

Unicorn

The unicorn is a magical horse with a single spiral horn in the middle of its head. It is ferociously strong and speedier than any hunter. There is only one way to capture a unicorn: A maiden must sit patiently and wait for it to place its head in her lap and fall asleep.

1 Sketch in the basic structure of the unicorn. Keep the lines fluid and dynamic. Notice how the head is twisting to one side. The mane and tail are moving in the same way, indicating movement or wind direction. The unicorn's proportions are closer to those of a pony or a goat than a stallion.

2 Begin blocking in the anatomical details using your structure as a guideline. The lines are fairly soft and rounded. Keep the eyes large and expressive.

3 Add some details such as the spiral horn, the eye and the hooves. Add other details such as flowers and grass to help ground the drawing and give it a sense of place. Keep the forms simple; you don't have to draw every hair.

Magical Cups

Unicorn horns are prized because from them could be made magical cups that revealed whether a drink was poisoned.

Mistaken Identity

There are many theories about the origins of the unicorn, but the most enduring story involves texts such as Pliny's *Natural History* published in 77 AD which included reports from ancient travelers about the rhinoceros. Readers formed fanciful mental images of it as some magical horse of the forest, not a lumbering beast of the savannah. When you look at the rhino and then at the unicorn, you realize that there was some serious miscommunication going on!

Stories of unicorns have circulated in Asia for thousands of years. The Japanese unicorn (kirin), could sense guilt and would execute criminals. It symbolized justice and retribution.

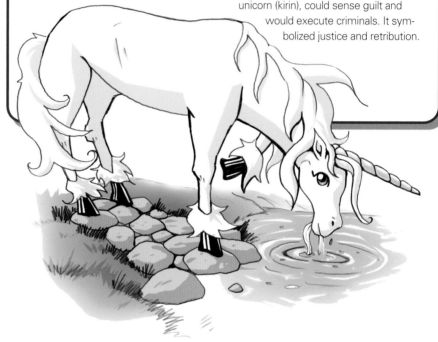

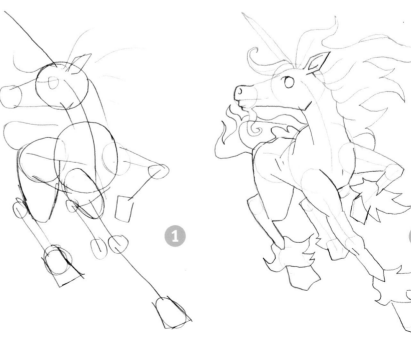

4 Ink the drawing, making sure you have a variety of lines that move from thick to thin, indicating mass and volume. Fill in the hooves, but leave some areas of highlight so they won't look too flat. The rear left leg has been left blank because it will be shaded as a solid dark gray in the final image. Adding too much detail would bring it forward visually. Carefully erase the pencil lines after the ink dries.

5 Use minimal, uncomplicated colors. Make the areas of shadow and highlight correspond to the highlights on the eye and hooves. Some indication of grass and flowers should be completed at this stage.

Dwarf

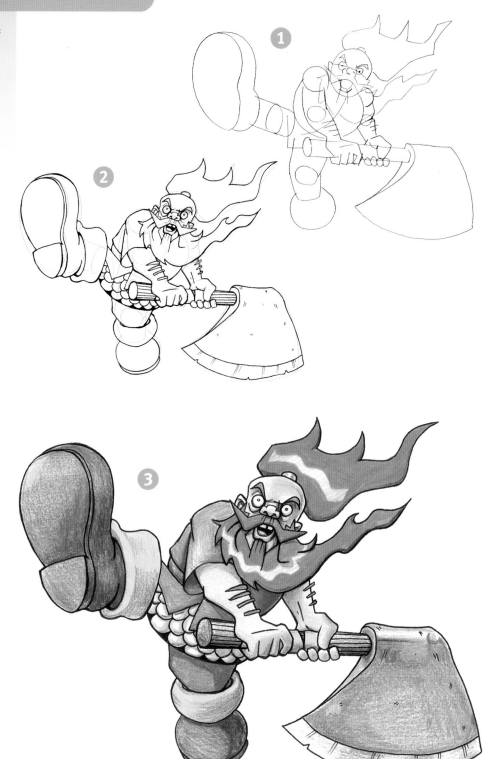

Stories of dwarves developed out of Norse mythology. Dwarves were the first things to stir on the Earth and were created from the body of the giant Ymir. Dwarves lived under the Earth and their treasures and weapons were legendary. They were considered excellent craftsmen and were so adept at metal work that they became smiths to the gods.

Other stories claimed that the dwarves lived underground because they turned to stone in sunlight. In high fantasy, dwarves are loyal companions and fierce warriors adventuring for gold and glory.

1 Draw a dynamic pose with extreme foreshortening of the right leg as the dwarf prepares to swing his mighty axe. Make the hair and beard appear to be flying. Make the mouth open and the eyes wild. So much can be stated in this simple sketch. Be as expressive as possible in your initial drawings.

2 Add information such as the beard, scale-mail skirt and big boots. This will hide your original anatomical work, but by paying attention to the underlying structure, you'll have a very solid-looking drawing. Little details such as the gap in the teeth, the hair tied in a topknot and the hairy arms add character and personality to the image.

3 Clean up the basic structure and make the clothing and axe appear more 3-D. Erase extra pencil lines and carefully shade and color the drawing. Keep in mind the range of light and dark as you indicate the areas of highlights and shadows.

Gargoyle

*T*he original gargoyle was based on a seventh-century French legend of a struggle between the Archbishop of Rouen and a dragon named Gargouille (literally meaning throat) that lived in the Seine River. The dragon was destroying the land by spitting not fire, but water. The dragon was tamed, taken to Paris, killed and burned. Gargouille's head was then mounted on a building as a trophy.

Subsequent generations of stone carvers have designed countless variations of this grotesque and bizarre creature as a remembrance of victory over evil and to scare evil spirits away from cathedrals.

Fantasy gargoyles are stone creatures that have magically come alive, usually to defend a building from intruders.

1 Express movement and power in the pose. The wings are way too small to be of any help, but draw them in anyway. The claws and horns should be dangerous and powerful. The anatomy is kept somewhat blocky—remember, this creature was originally carved out of stone.

2 Carefully add anatomical details, emphasizing dragon-like features and reinforcing the stone-carved look. Keep the lines bold and vary the thickness to reveal form and structure.

3 Clean up the stray pencil lines and shade the drawing to look as if it were carved out of stone. Make the gray appear richer and liven up the drawing with subtle additions of colors such as blue and brown. Add surface details such as cracks and marbling to make the gargoyle appear more stone-like.

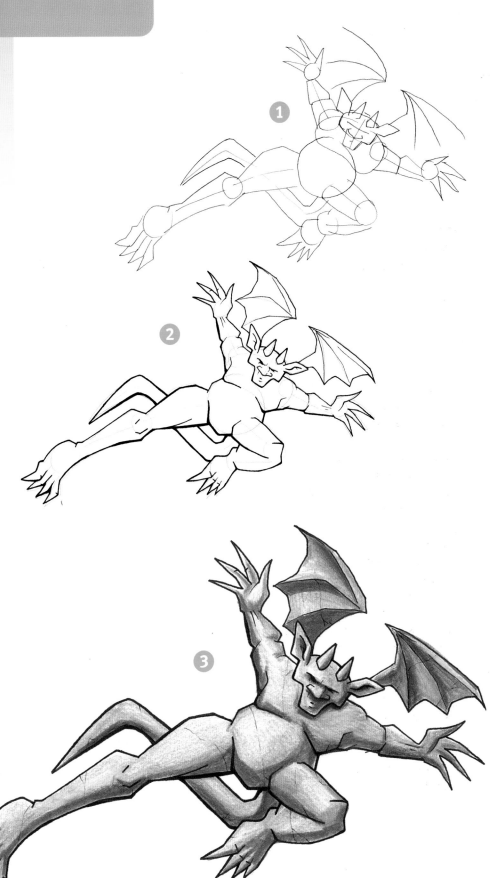

zombie Lord

The Zombie Lord is a dangerous, undead opponent with a legion of skeletons and zombies ready to do battle with the living. Usually a powerful wizard, the Zombie Lord controls the undead using necromancy, the magic of death.

1 Draw the character as you would any figure. The body should be powerful but lean. Exaggerate the teeth for expression and make the face more skull-like. Minimize the remaining details for effect. Make the fingers long with claws at the end, much like skeletal hands that appear claw-like.

2 Add details to make the image convincing. Just in case it isn't clear that this guy is associated with the evil dead, give him skull-shaped shoulder armor and a big skull belt buckle. Also have him holding a scythe, another symbol of death. Make his clothes and armor ratty and decrepit. The wrappings on the arms and legs should be mummy-like.

3 Choose a skin color that looks unhealthy. Purple hair indicates knowledge of secret magical information. Make the blade of the scythe appear reflective and metallic. Metal has strong highlights and areas of shadow, unlike the smoother shading of the skin and cape.

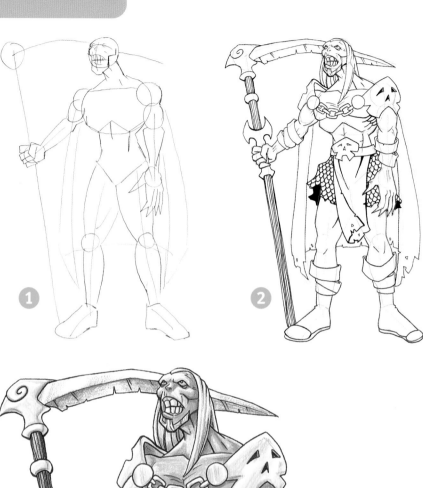

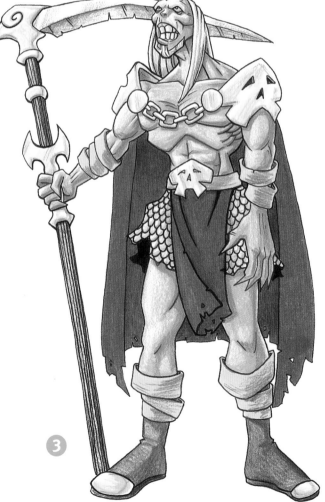

knight and Warhorse

When the stirrup was introduced in Europe in the eighth century, a new class of warrior developed: the knight. The warhorse was important for the medieval knight because it allowed a tactical advantage against standard warriors. A mounted warrior was a more difficult target. The horse could move around the battlefield quickly and knock people out of the way.

The most challenging part of drawing someone riding a horse is not making the rider appear too big or too small.

1 The information from the section on drawing quadrupeds (page 19) should help you at this stage. Make sure you draw the rider leaning forward, as most of the weight of the horse is on the front legs. Make the front legs of the horse close together to propel it forward. Keep the hair and cape dramatic to go with the motion indicated by the pose. Rider and horse should work as one, charging across the landscape.

2 Add important details such as the armor and riding equipment. Use references when you can for the weapons, armor and anatomy. It's important for the muscles and riding equipment to be accurate. The horse cannot be directed without a rein and the knight would fall off the horse without the stirrups and saddle.

3 Use the coloring and shading stage to bring everything together in this complex image. Keep the light direction consistent; areas of highlight and shadow should not contradict one another. The mane and tail have some hair detail, but it is not overly complicated or overwhelming. Keep things simple and understated. Too much detail in one area can be distracting and ruin the overall effect of the drawing.

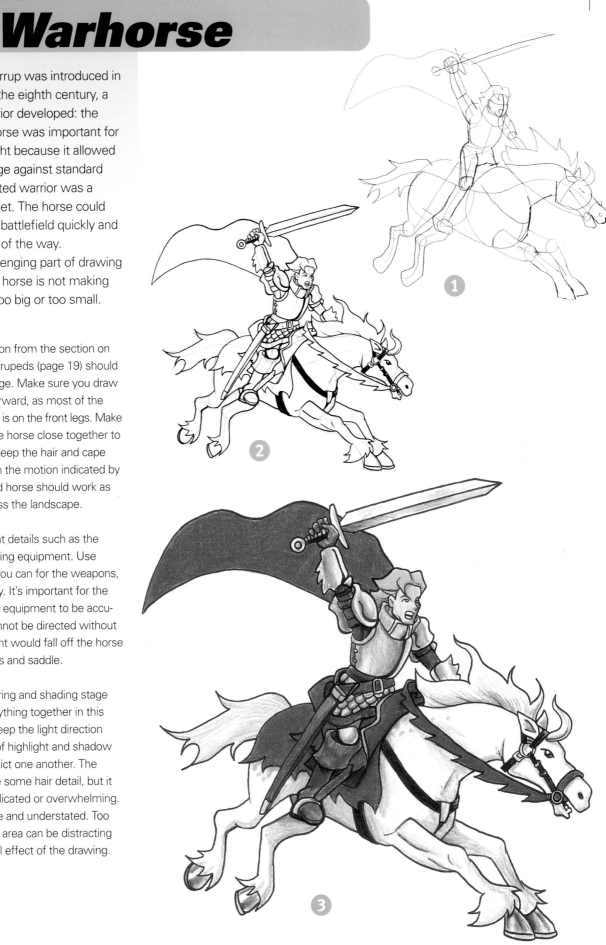

Daikaiju:
giant monsters

Giant monsters were one of the first cultural imports from Japan in the 1950s. Originally developed to criticize the destruction and dangers of nuclear testing and warfare, giant monsters spawned by radiation and explosions represented the inhumanity and destruction of war. Countless films and television series have been made featuring daikaiju. The giant monsters sometimes evolve into the heroes of the story as defenders of Japan or even the Earth. Daikaiju have appeared in popular video games and manga. They are included in this book because they are such an important cultural commodity and they represent a common theme in manga monster stories: "Don't mess with nature!"

Daikaiju characters are also just fun to draw in action, stomping on buildings and eating tanks. And from time to time, magna heroes will meet up with giant monsters, so it's a good idea to know how to draw these things before the action starts.

Tyrannosaur

This terrible lizard was the dominant predator of the Cretaceous Age. Daikaiju stories of lost worlds or time travel often include a rampaging dinosaur or two to keep things interesting. Tyrannosaurs were around fifteen feet tall and roughly forty feet long. They weighed as much as six tons and had strong jaws full of six-inch-long serrated teeth.

Tyrannosaurs were effective hunters. Draw them sleek and graceful, like a coiled spring; avoid the clunky dinosaur look.

1 Keep the initial drawing quick and loose. Focus on the pose and action lines. The jaw and neck muscles should look strong, but the forearms should look small and useless. The tail should help to counterbalance the front-heavy creature. Use simple guidelines at this stage and avoid too much detail. You don't want to have to erase all your hard work if you make an error.

2 Block in the details, keeping the forms rounded and cylindrical, never flat. Draw the wrinkles and other anatomical details to show the 3-D form. Draw muscular feet that end in sharp talons.

3 Keep the details of the claws and teeth consistent. They should appear as 3-D forms, not flat cutouts. To avoid confusion, tighten up your drawing and erase extra structural lines.

Tyrannosaurus Wrecks

Rampaging monsters such as the tyrannosaur or smaller velociraptors are dangerous because they are wild predators with a deadly combination of power and cunning. Not as large as some daikaiju monsters, the tyrannosaur is still a dangerous opponent for a group of heroes.

The manga *Gon* focused on a young tyrannosaur and his rampaging misadventures. The fierceness and power of the predator became fodder for jokes.

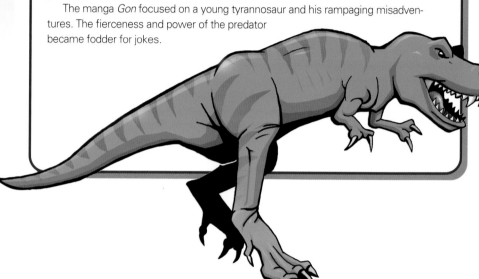

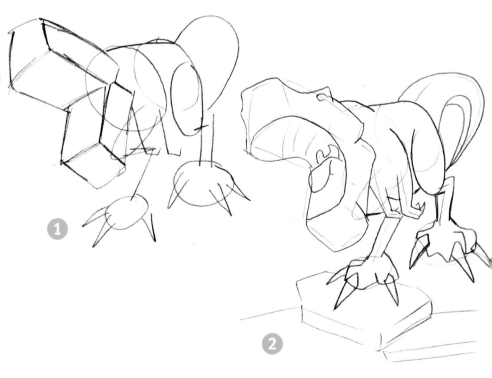

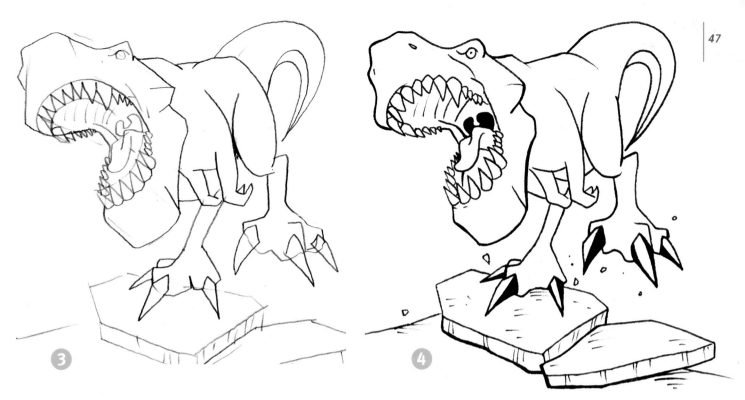

4 Make the final inked image with a degree of line variety to give it a real sense of form. This form will be obvious after you erase the pencil lines.

5 When you finish the image, try to maintain a consistent light direction. Know where your shadows and highlights will be before you begin shading (the skin does not have to be a solid color). Dinosaurs may have had patterns or markings like today's predators. Tigerlike stripes or leopard spots may not be too unusual for these ancient predators.

Form and Movement

Capturing the 3-D form and sense of movement in the earlier steps will create a dynamic and dangerous presence. This creature is on the hunt.

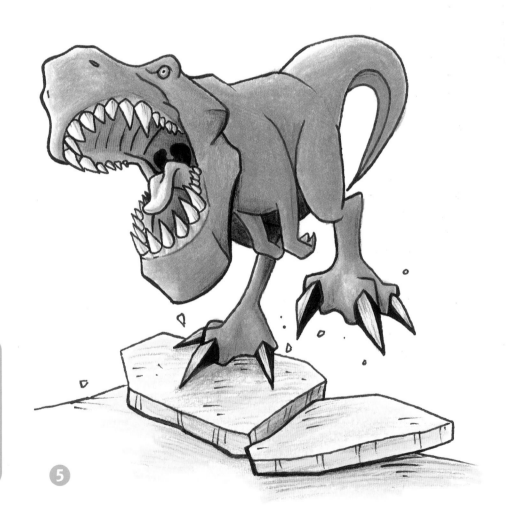

Triceratops

Next to the tyrannosaur, the triceratops would easily come in a close second in a coolest-looking dinosaur competition. A plant eater, the triceratops developed the classic three horns as a defense against predators. A circle of well-armed triceratops defending the herd would be an imposing sight for any dinosaur. The triceratops was twenty-eight feet long, eight feet tall and weighed over seven tons. It lived sixty-five million years ago in the western United States and Canada.

1 Position the triceratops in an extreme and dynamic gallop. Make the creature running full tilt, right at the viewer. The front legs are planting firmly and the rear legs are propelling the beast forward. Keep the forms simple at this point, blocking in some of the details as you go.

2 Carefully add the surface details. It's helpful to erase extra construction lines, as they can become confusing and distracting.

Use Structural Lines

As you become more confident with your drawings you might feel that you need fewer structural lines, but I've found that structural lines are still a good idea to prevent possible distortion and anatomy problems.

Animated Giants

Did you know that one of the first animated creatures was Gertie the Dinosaur by Windsor McCay in 1914? McCay was also known for his groundbreaking comic strip *Little Nemo in Slumberland* (1905–1911). His attention to detail, beautiful craftsmanship and amazing perspective skills created a comic strip that revolutionized sequential storytelling. He was also pretty good at drawing dinosaurs.

McCay's influence can be seen in the work of early manga artists, particularly Osamu Tezuka, creator of *Astro Boy* and the recent *Metropolis*. A film version of *Little Nemo in Slumberland* was produced in the 1980s by Fujioka Yutaka.

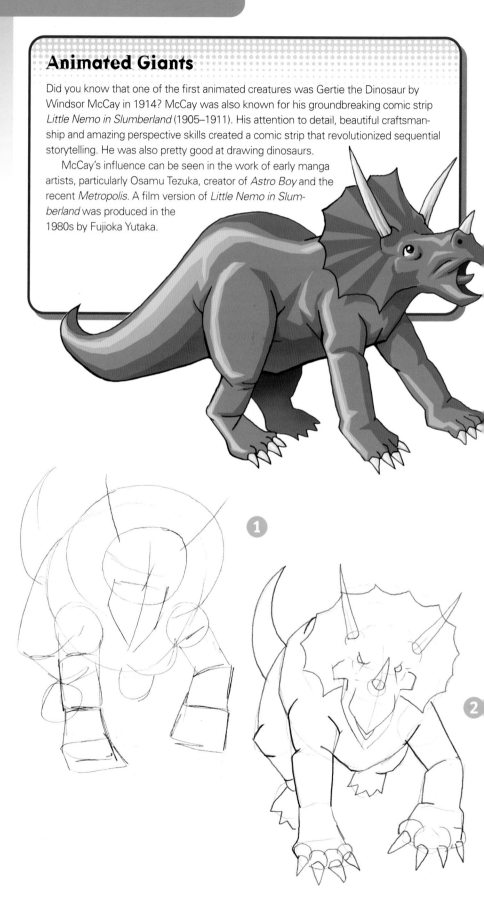

3 Add details such as the claws and wrinkles on the skin to provide more information and to make the image more realistic. Details such as grass can be added to give a sense of place and scale to your image.

4 Carefully finish the details and anatomy as you ink the drawing. When the ink is dry, erase the pencil lines and clean up the image.

5 Shade and color the drawing, keeping one consistent light direction. Use complementary colors to shade the areas of shadow. Notice how a slight highlight on the shadow side gives the illusion of reflected light and adds to the realism of the image. This guy looks mad about something.

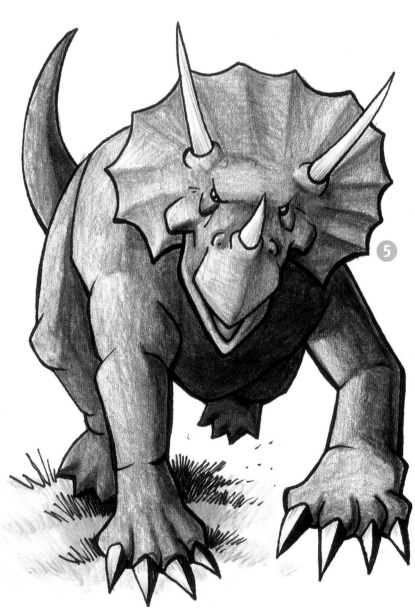

giant Ape

Since the release of *King Kong* in 1933, the giant ape has been a staple in daikaiju films. One of the most famous scenes in film is the image of King Kong on top of the Empire State Building. It seems hard to believe, but even Godzilla battled a much larger King Kong in the 1962 film *King Kong vs. Godzilla* and the classic 1967 film *King Kong Escapes*, which introduced the wonder of Mecha Kong. The giant ape theme also occurred in *The Adventure of the Gargantuas* (1966).

King Kong helped to define the genre and made the giant ape one of the more traditional daikaiju monsters

Monster Island

King Kong helped define many of the traditions that later became standard in daikaiju movies. One of the main concepts was that of a special island, forgotten by modern man and home to all manner of giant creatures. Monster Island has also been the home of lost civilizations from Atlantis to Lemuria and the base for alien invaders bent on taking over the Earth.

The precise location of Monster Island is never accurately described. Sometimes it is in the South Seas; other times it is close to mainland Japan. It was the primary location for the Japanese TV series *Zone Fighter* (1973).

1 Use basic lines and ovals to block in the anatomy. In the daikaiju film tradition, a man in a rubber and fur suit usually plays the monster. Therefore you should extend the arms to appear apelike, but make the anatomy less apelike and more human. The pose should be strong and powerful, as if the creature is beating its chest.

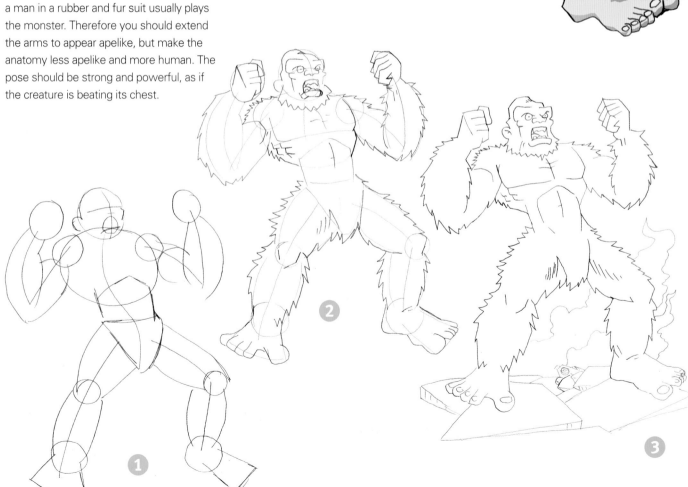

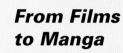

From Films to Manga

Evidence of giant apes and monkeys appears elsewhere in manga and anime. In the original *Dragonball* manga and anime, Goku turns into a giant rampaging monkey when he looks at the full moon. And who can forget the lovable Donkey Kong from many successful Nintendo games?

2 Add details such as feet, hands and facial features. Block in the fur and make the head more gorilla-like in appearance.

3 Clean up the extra pencil lines with an eraser and add the ruined street. Show smoke and dust rising from the rubble and draw a demolished car that is just noticeable in the background. Keep the image as simple as possible at this point; extra lines will appear confusing. Every line should describe something. Use colored pencil for the shading.

4 Ink the image and when the ink is dry, erase the pencil lines. Remember to vary the thickness of the lines to add areas of shadow and mass. This helps your drawing appear more polished and 3-D.

5 Make sure the areas of light and darkness seem to relate to a common light direction. Highlight the fur to give the ape a 3-D appearance. The giant ape looks like he is ready to battle the giant lizard!

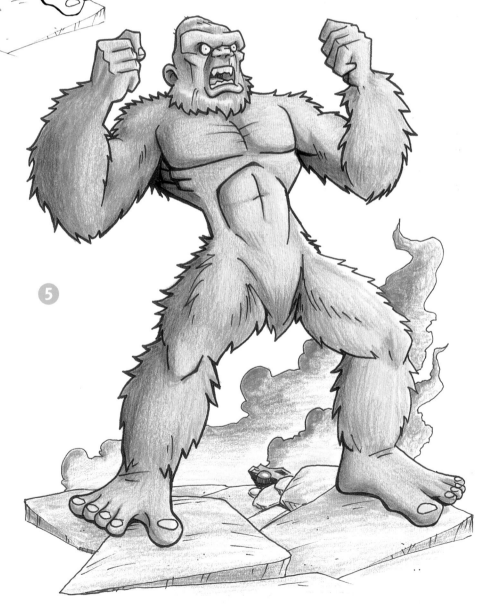

giant Lizard

*B*ecause of the colossal success of Godzilla and his imitators, when people think of giant monsters they usually think of a giant lizard. The giant lizard is usually a combination of a dinosaur and a dragon, and it has been invented and reinvented in countless films, television shows, anime, manga and video games.

Ishiro Honda, the director of many Godzilla movies, wanted to make the daikaiju into something more than just a rampaging beast. He wanted the audience to connect with the character of the monster. Honda recognized that daikaiju have a tragic beauty and did not choose to be evil. Daikaiju are just born too tall, too strong and too heavy for the world around them.

1 Keep things simple. Begin the drawing with standard circles and tubes. Make the figure appear humanoid in recognition of the fact that most of these creatures were actually men wearing rubber suits stomping on miniature models.

2 Block in the features with more detail. Carefully indicate the teeth, claws and spines along the back. Also indicate some surrounding rubble and smoke.

3 Finish the lines and add detail to the mouth and the rubble. (The eyes will later be colored in as if they were glowing.) Make the tail look as if it were swaying from side to side.

Monstrous Manga

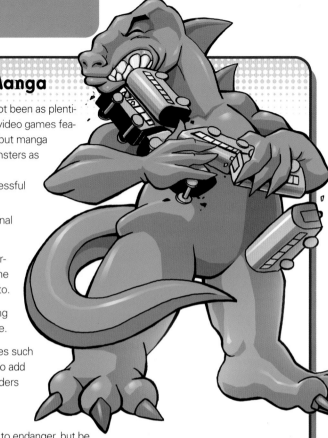

Daikaiju manga have not been as plentiful as the film, TV and video games featuring giant monsters, but manga often include giant monsters as part of the storyline.

Some keys to successful daikaiju:

- Create cool and original monster designs.

- Give the monster personality and quirks the audience can relate to.

- Draw lots of stomping and property damage.

- Combine other genres such as aliens or fantasy to add variety and keep readers guessing.

- Include one or two human protagonists to endanger, but be sure to make them "likeable" or the reader won't care about their fate.

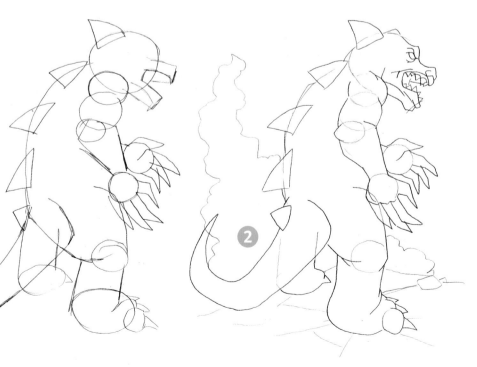

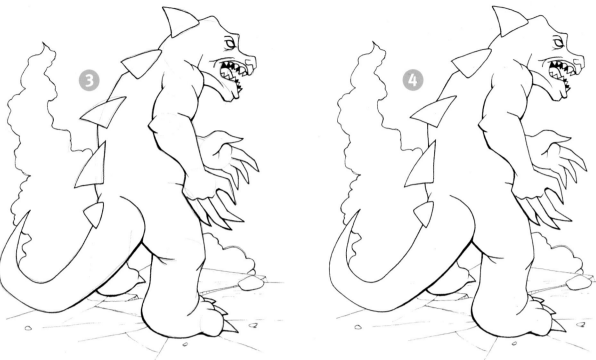

④ Finish inking your drawing and clean up any stray pencil lines. The ground seems to be literally collapsing under the massive weight of this beast.

⑤ I chose green for this monster, but almost any color variation will work. The gene that controls size also controls skin color; that's why large creatures such as whales and elephants are often not very colorful. This is a fantasy, however, so make the monster as colorful as you like. The fireball that is raging behind the lizard could be a burning oil refinery or a military assault on the enormous creature. The fire should illuminate the cloud of smoke and the side of the creature. Keep the lighting dramatic and make sure it is defining structure properly.

A Man in a Rubber Suit?

The physical limitations imposed by the fact that the monster is really a man dressed up in a rubber suit somewhat restricts the potential character design, but daikaiju creators have always found interesting ways around the problem.

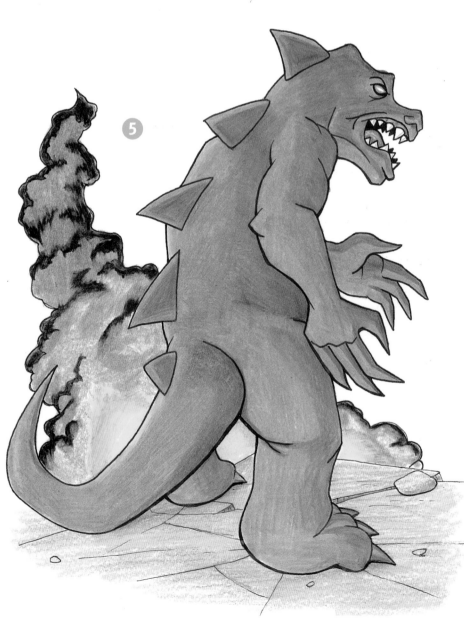

giant Robot

Giant robots can be anything—alien invasion machines, out-of-control artificial intelligence, or even the weapons of an anti-giant-monster squad. Some giant robots have even been known to grow from human size to giant monster proportions.

1 Begin the drawing by blocking in details. Be sure to keep things simple at this stage.

2 As details are added, try to keep in mind the 3-D geometric forms of what you are drawing. The head, torso, arms and legs are cylinders.

3 Make small details such as the knobs on the shoulder units and the knees appear to wrap around the sphere and not sit flat. Keep the essentials consistent and unify the design by repeating elements. For example, all air vents should be round, as they are on the shoulders and forearms.

10 Possible Purposes for Those Shoulder Units

1. Heavy metal projectiles attached by retractable chains

2. Cosmic energy power collectors

3. Dual escape pods for the crew

4. Magnetic electrical charge bombs

5. Force field generators

6. Stabilizing gyroscopes for balance

7. Solid fuel tanks

8. Multiple micro missile launchers

9. Hydraulic fluid canisters

10. Connection clamps for combining with other robots

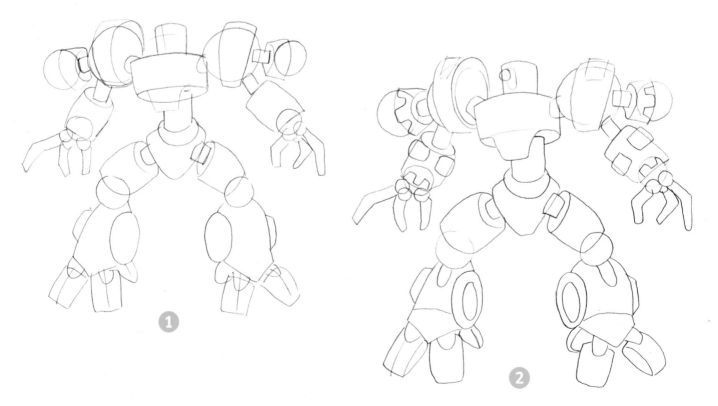

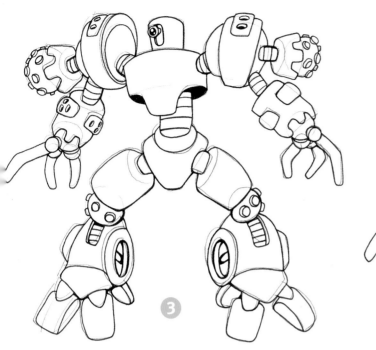

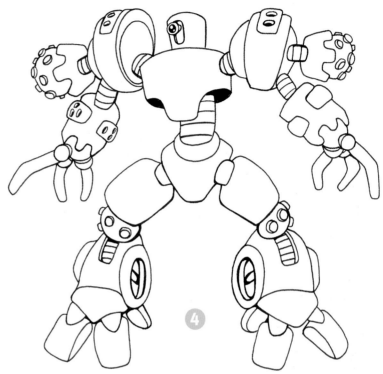

4 Clean up the final inking and erase the original pencil lines. This is a good time to decide what all those cool design elements actually do, because you just know someone is going to ask, "What do those things on the shoulders do?"

5 Try to show the roundness of the forms as you draw with the colored pencils. Using dramatic lights and darks will make the robot appear more metallic, which is the effect you are probably looking for. Hmm, what do those shoulder units do, anyway?

It's Your Creation

The structure of the robot is totally up to each artist. This robot obviously follows standard humanoid proportions, but some features—such as the shoulder attachments, the two fingers and two toes and the cylinder head—create a more mechanized appearance.

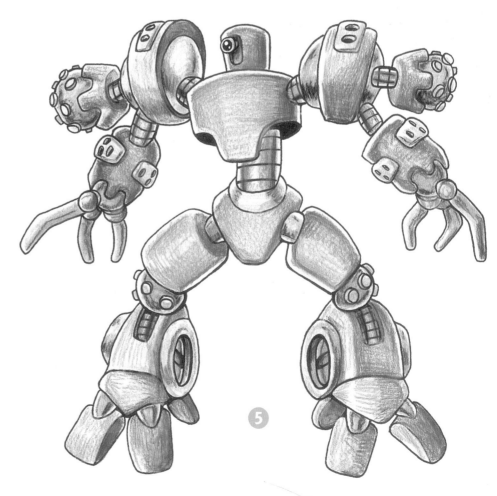

Pterodactyl

The pterodactyl is one of the most recognizable giant lizards from the prehistoric Jurassic period. Some pterodactyl had a wingspan of over sixty feet. Pterodactyl wings were covered with a leathery skin attached to one of the fingers. The other fingers ended in claws.

Some pterodactyls had an aerodynamic fin on the back of their heads, probably to help them dive faster and move more precisely. The teeth were useful for catching and holding their prey as they dove out of the sky. Daikaiju pterodactyls tear the shingles off houses as they fly by and can flip tanks with a flap of their wings.

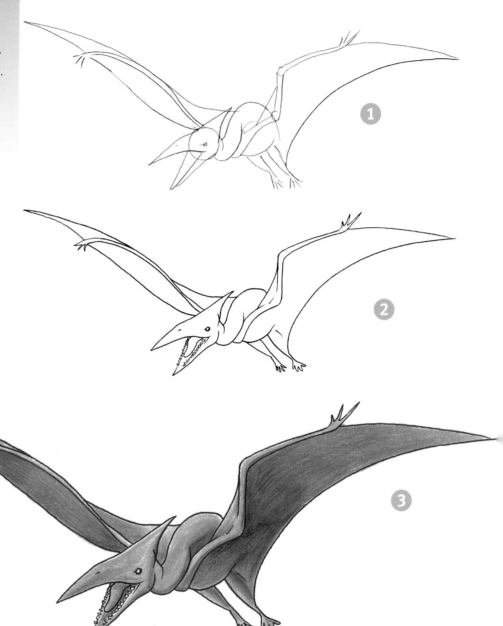

1 Block in the basic shapes. The wings attach on the side of the legs and along the sides of the body.

2 Clean up the lines and pay particular attention to details such as the tiny fingers that protrude from the top of the wing. The fourth finger forms the remainder of the wing.

3 Green seems like a natural color for the pterodactyl, but no one knows what color the leathery skin really was. Try to make the image look 3-D. Don't forget to darken areas of shadow by using the complementary color. Red appears much richer than black and makes the green more vibrant.

Sea Serpent

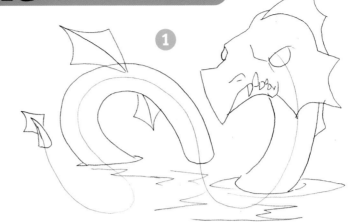

The sea serpent is one of the oldest forms of giant monster. Sailors have told stories of these creatures for thousands of years. The sea serpent generally stays in the water—but imagine everyone's surprise when the watery fiend drags itself onto dry land and begins bashing things.

1 Start with basic guidelines, keeping the lines fluid and simple. The sea serpent is really just a big water snake with a more dragon-like head.

2 Erase extra pencil lines and make sure the ink lines are crisp and clean. As you complete some of the details of the monster, pay attention to how you draw the water. Make the splashing water show movement by making the waves ripple around the creature as they rise and fall into the water.

3 Keep the direction of the light consistent as you draw. Make the skin appear smooth and sort of slimy. (The scales are too small to appear obvious from this distance. A close-up drawing might reveal some fish-like scales.) Softly draw in the water, including some areas of reflection, to add some realism to the final image.

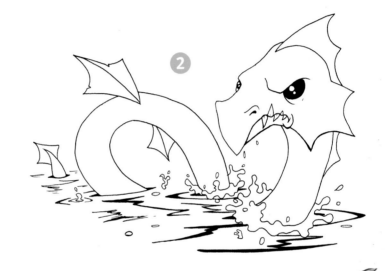

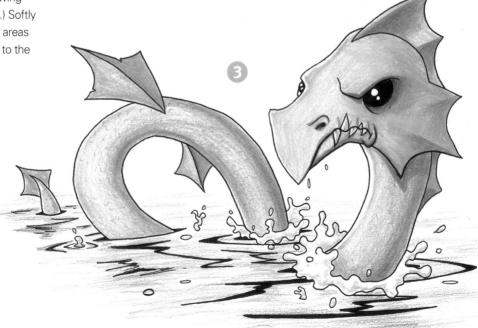

giant Insect

Most people hate creepy crawlies. The sight of a cockroach or ant in the kitchen can send even the most balanced person into a fit. Now imagine that the creepy crawly has grown to the size of a house—and it's hungry. Some classic daikaiju films have featured giant moths, praying mantises or ants.

You can learn a lot about insect anatomy as you draw it. You'll find that bugs are more interesting than scary once you get to know them.

1 Define the structure with tubes and spheres. Notice how the six legs all come out of the thorax (the midsection). This is almost like drawing a six-legged robot.

Draw some background to indicate the scale of the mighty monster.

2 Once the lines are cleaned up, the way the pieces of the exoskeleton fit together will become more obvious.

Do some research on details that you add might want to add, such as the spiky legs of the ant, the shape of the antennae or the bottom of the car.

3 Red ants just look angrier and more dangerous than black or brown ants. The surface of the ant should appear shiny and shell-like, with strong reflections.

Remember, ants are rarely found alone; where there's one, there's usually an entire colony.

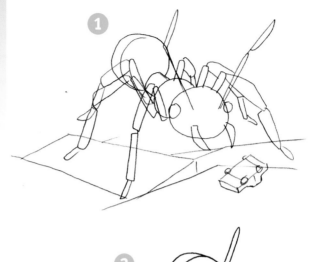

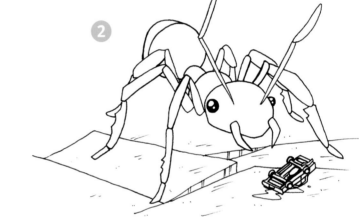

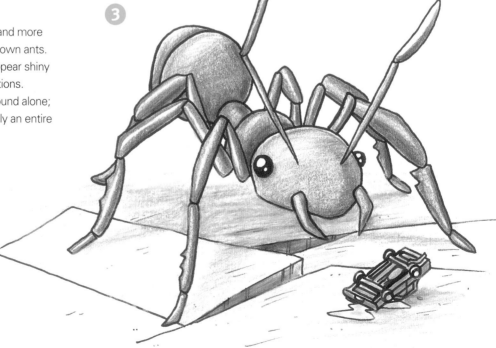

giant Spider

Spiders can scare even the strongest-willed person. They're fast, agile and very alien-like in appearance. Spiders are not insects; they are arachnids, a class of creatures that includes ticks, mites and scorpions.

Spiders have eight legs, two large feelers (pedipalps) for feeling things, and some nasty-looking fangs for holding prey and injecting poison. The web spinnerets are located at the back of the abdomen.

No matter where you go, you are never more than three feet away from a spider.

1 Try to keep everything simple as you block in the basic structure. The web spinnerets are not visible in this drawing.

2 Some spiders have very beautiful colors and markings. Don't feel bound by the rules of nature, though. You can make your spider appear however you like—after all, it is twenty feet tall!

Draw all eight eyes in rows on the head. Usually two sets of eyes are more prominent than the rest. Draw the markings on the spider's body with lines so they appear as if they were made up of fine hairs. Draw a few hairs on each leg.

3 The surface of the legs should appear shiny. The body should appear as if it were covered in short hairs. Look, the spider caught a bug!

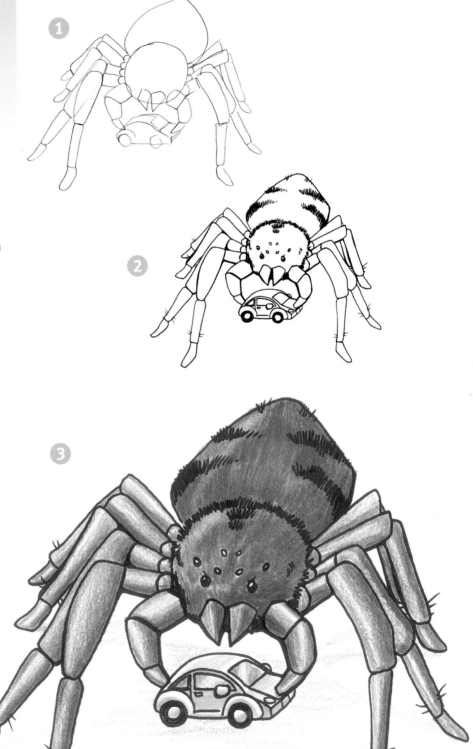

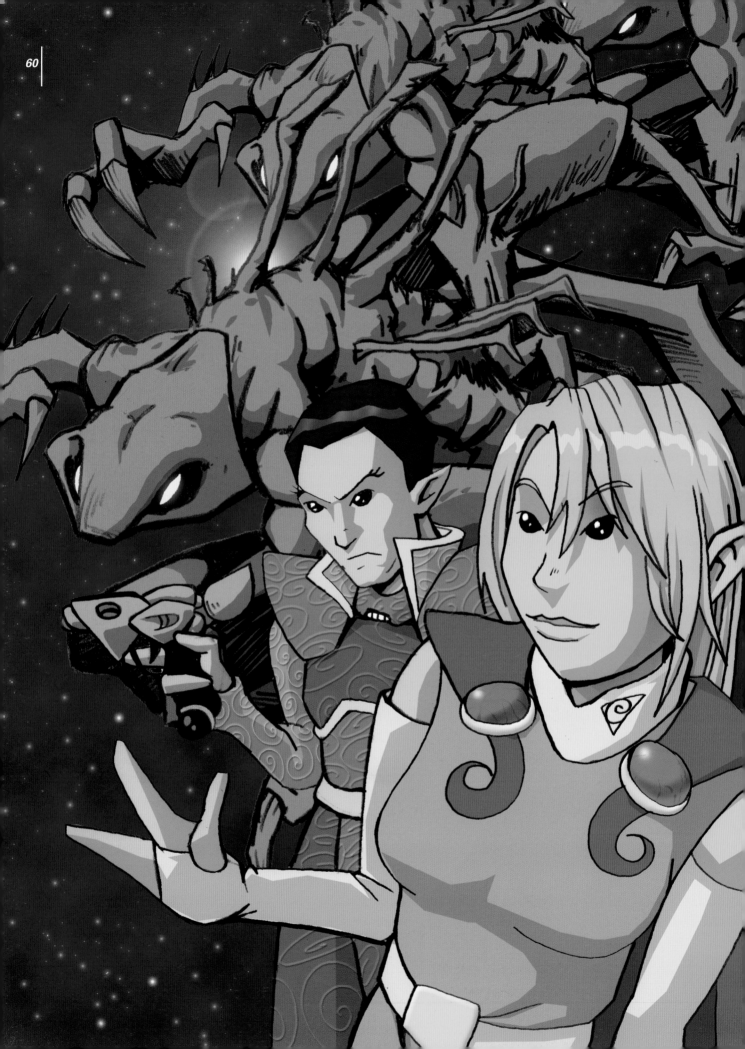

Aliens

The existence of life on other planets is rarely debated in manga. Aliens of all kinds fill the manga universe. They may be invaders attempting to destroy humanity, evil creatures unleashed upon an unsuspecting world or one might even be the dashing hero that zooms in and saves the day—again. With such variety of roles, it doesn't make sense to limit the possibilities of what could be "out there."

When drawing aliens, the rules of anatomy and biology can easily be broken. It's nice if you can explain why an alien looks the way it does, but the main focus of manga is not on reason but appearance. The idea is to make the images appear as "cool" as possible. Surprisingly, most aliens in manga are very human-looking bipeds with two eyes, a nose and a mouth. The reason for this is not a lack of research or imagination; it's just easier to believe in a romance between an intergalactic invader and a human warrior if the aliens are physically more similar to humans than giant space insects.

invader Warrior

This is a good example of an alien that looks different from a human but still has enough humanlike elements to seem plausible. A basic "space marine," the invader leaps from the capsule and starts shooting. This warrior is wearing an armored spacesuit and holds a nasty-looking bolt pistol.

1 Start with the basics. Use sticks and circles to block in the anatomy.

The most striking features at this stage are the digitigrade structure of the legs (see page 18) and the two big "toes" on the feet.

2 Block in the details and add the elements that will become the armor and the pistol. Continue drawing as if you can see through the figure to make sure the anatomical structure is not distorted. This will be erased in the final stages of penciling so that it is not confusing.

3 Erase the extra pencil lines to get a clearer idea of what the final drawing will look like.

4 Ink the drawing and clean up any confusing or inaccurate lines. Make sure the ink lines vary in thickness to reflect the mass and weight of the figure.

5 Shade and color the image. The armor may be a little tricky because it needs to be somewhat reflective. Show strong highlights, shadows and reflections to create a metallic appearance.

The green orbs are a design feature that can easily be extended to other technological devices used by these aliens.

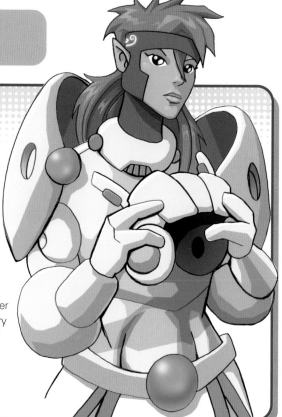

Tragic Love

It's true: Many alien-invasion manga stories become tragic tales of forbidden love. That's what makes manga and anime so accessible. Behind all the plasma-beam warp cannons, giant robots and alien monsters is a very "human" story full of emotion and intrigue. Love may conquer the inhumanity of war, or the lovers may become tragic victims of the conflict. Either way, love is eternal and the story rises above the expectations of standard science fiction.

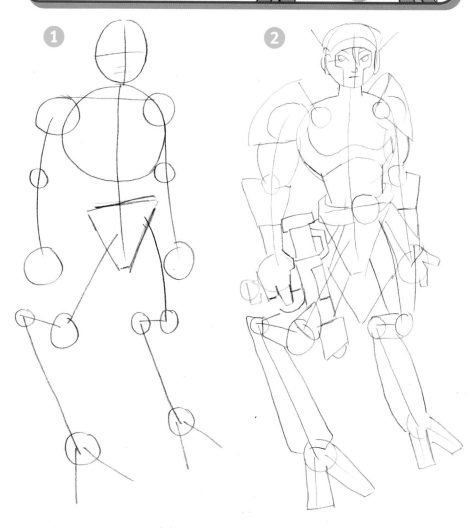

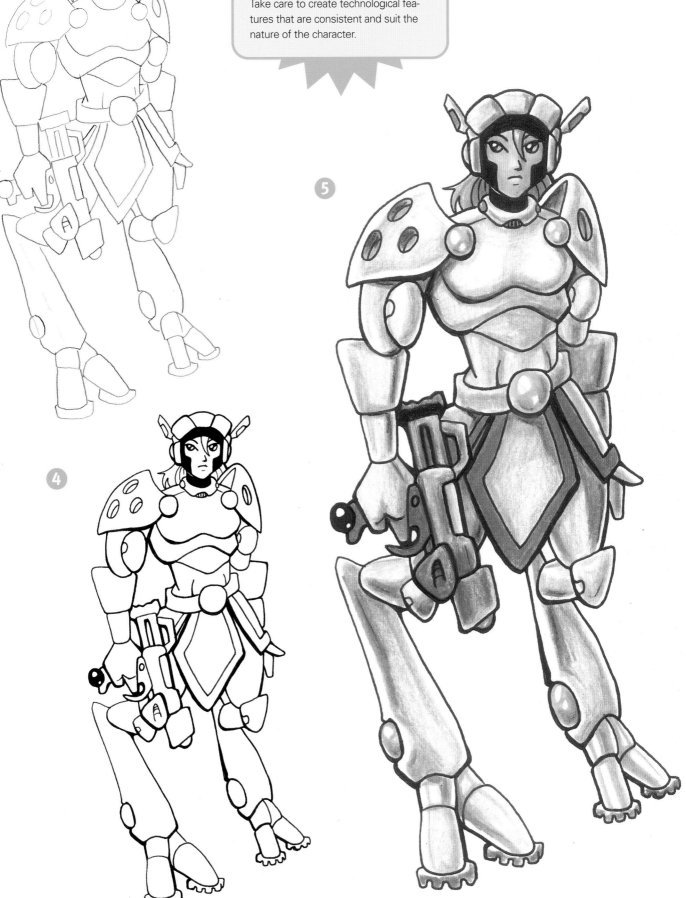

Creating Features

Take care to create technological features that are consistent and suit the nature of the character.

invader Leader

*I*n some manga and anime stories, invader leaders provide comic relief, reporting back to some higher power time and again with failure after failure. Other invader leaders are brilliant strategists and honorable warriors quickly winning the respect of their opponents. Invader leaders are often mutated or covered with a mask or armor to make them appear less human than other alien invaders.

1 Block out the basic structure, paying attention to the details that make the character appear distinctly alien.

In this example, the digitigrade legs and two toes make the character appear alien. Note that the chest appears wide and powerful and the head is leaning forward. This is a very strong, stable pose.

2 Make the details and finery of the alien leader similar to that of the warrior, but make sure there are some noticeable differences in the costumes. Make the helmet cover the entire head and include a built-in breathing apparatus. Make the shoulder armor elaborate so the leader seems larger.

Earth Invasion

Make the alien leader more than just a snarling villain. Give him a really good reason to invade Earth, like a natural disaster on his home world or some ancient claim to Earth.

The cape adds a regal touch. Capes in space?

Take Me to Your Leader

Alien leaders are sometimes the most interesting aspect of anime or manga. It's fun to create the cultures and design the "look" of the aliens. Some artists and writers like to reference existing Earth cultures for inspiration, often combining or reversing beliefs, practices and appearances.

Alien leaders are often scarred, mutated or somehow even less human than the other alien invaders. Also, they often possess magic or mental abilities that make them more powerful and therefore stronger—and scarier—leaders.

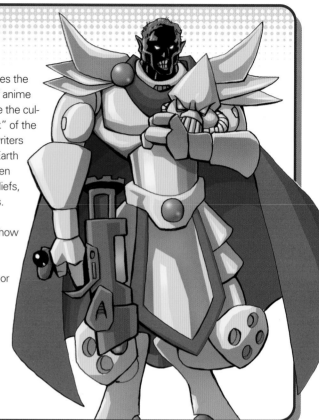

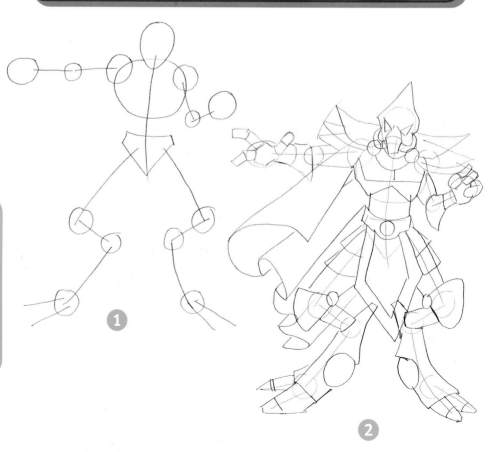

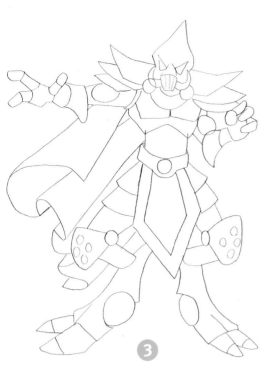

3

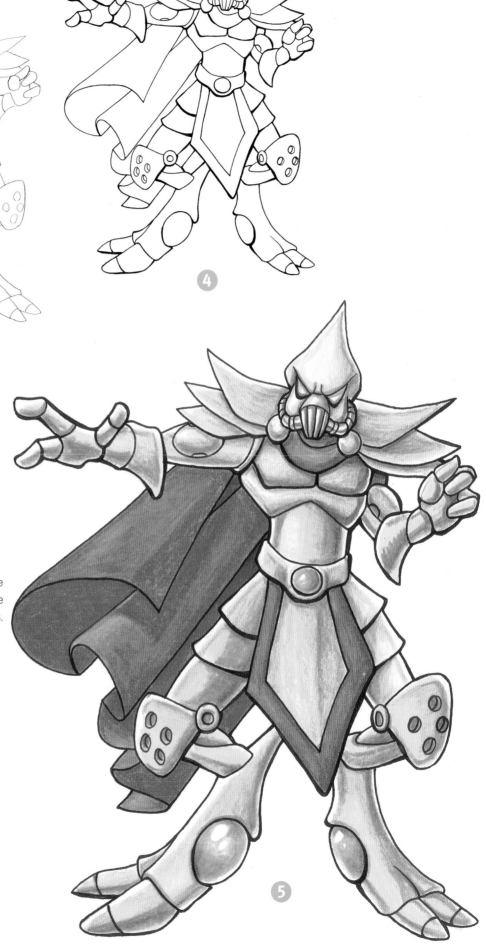

4

5

3 Clean up the details and fine-tune the proportions and anatomy. Make the technology of the armor clearer at this point. The overlapping armor and articulated joints should be consistent.

4 The inking stage should clarify the drawing, not muddle it up with extra lines and scrawls. Keep the ink lines crisp and clean, never scratchy. Remember to vary the thickness of the lines to reveal 3-D mass and structure.

5 Make the armor reflective, just like the alien warrior, but color it to appear more golden by using yellows, browns and oranges. Leave areas of white to create a shiny, metallic appearance.

Try this technique on a couple of rough drawings to get the hang of it. Make sure the light is coming from the same direction in each area of your drawing.

Invader Beast

Sometimes the alien isn't something you can negotiate with, or the invaders might have these beasts as a sort of "secret weapon" in their invasion arsenal. Whatever the case, the invader beast is an almost unstoppable adversary. This monster appears to have elements from lizards, insects and sea creatures combined into one very scary package.

1 Block in the figure with circles and sticks just as you would any other drawing. Keep in mind any unusual anatomical details as you draw, such as the tail and digitigrade legs.

2 Flesh out the figure and add specific elements such as the claws and fangs. Strange spikes seem to rise from the back and forearms. The purpose of these spikes isn't obvious at this point; they could be weapons or a defensive feature, or even a social adaptation (such as peacock feathers).

Monster of the Moment

Alien monsters are great enemies in manga. The appearance and abilities of the creatures can be changed from story to story to create the standard "monster of the week" that is found in popular magical girl, sentai manga and anime. The format works very well when combined with a strong, character-driven story.

Eventually the focus of the manga will be the characters and what they are going through emotionally, as opposed to what funky monster will be beaten up this week. The funky monsters are the "hook" that gets readers to understand the characters better. Having nothing but funky monsters is fun for a while, but readers eventually will get bored. Try to create stories and characters that readers can relate to.

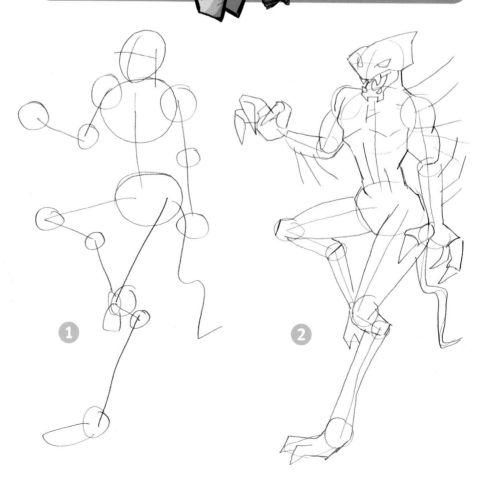

Bred in Holding Tanks?

This alien seems to be a sleek predator that would hold down its prey with its claws. The oversized canines indicate that it probably uses its mouth to tear flesh. The wedgelike head suggests an aquatic origin. Perhaps this beast is bred in holding tanks aboard the alien invasion fleet and then unleashed onto the battlefield to "soften up" the enemy before the invasion begins.

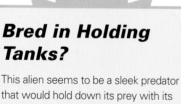

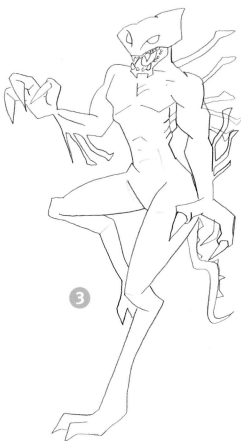

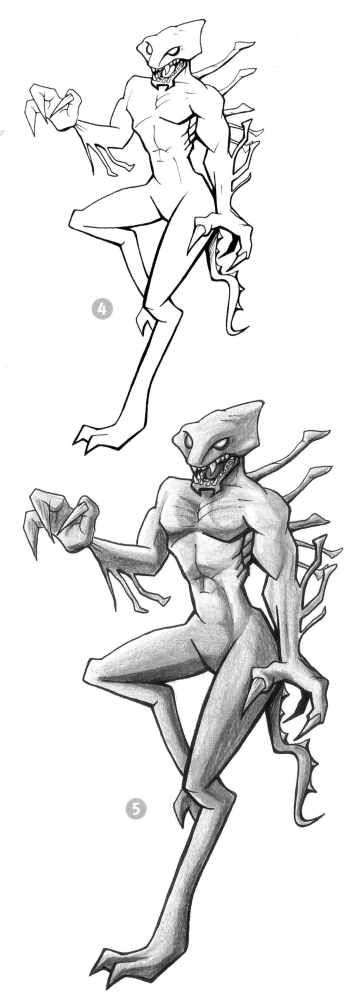

3 Clean up the details and complete some of the anatomical elements of this inhuman creature. Make the figure appear lean and powerful but not overly muscular.

4 Clean up the pencil lines and carefully ink the drawing. Use the ink lines to show depth and form. Thick lines come forward and thin lines recede. Thick lines also show areas that are darker, indicating the source of the light.

5 Use a neutral gray for the skin tone because this creature has to blend into any environment. A brightly colored predator would find it difficult to hunt its prey. The creature may have some chameleon-like ability to blend into its surroundings, or it may release a chemical from those spikes on its back to confuse or incapacitate those unfortunate enough to meet it.

alien
Monstrosity

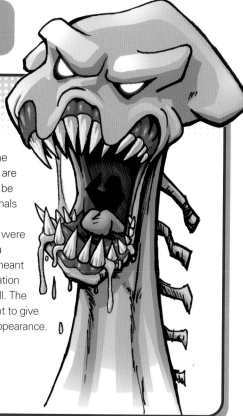

If you thought the invader beast was horrifying, meet the granddaddy of them all: the alien monstrosity. This could be a separate entity or it could be what the invader beasts turn into after a period of hibernation. The alien monstrosity should be large and imposing, an almost unstoppable creature that can flip tanks and crash through blast doors.

① Begin the drawing by blocking in the figure with sticks and circles.

② Flesh out the structure to create a very imposing monster.

③ Clean up the extra lines to reveal a lean, mean hunting machine. Make this creature look like all claws and teeth. Develop the details of the spikes, teeth and claws. Don't forget the fins running down the back of the tail.

Oh the Inhumanity!

When designing aliens, you don't have to follow the same rules as for earthbound creatures. The less human they appear, the more terrifying they will seem. When you are designing your own alien monsters, don't be afraid to combine features of existing animals together in new and unusual ways.

The claws on this monstrosity actually were inspired by walrus tusks and the arms of a praying mantis. The body was obviously meant to be snakelike, and the head is a combination of the praying mantis and an elephant skull. The spines and fins along the back were meant to give the creature a slight lizard or dragon-like appearance.

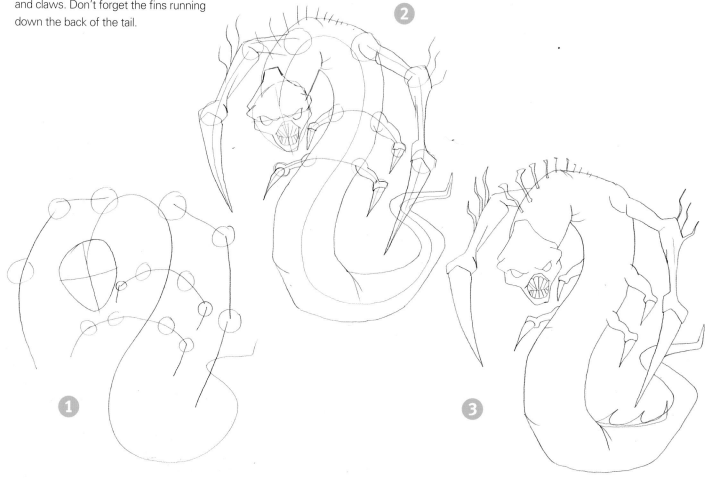

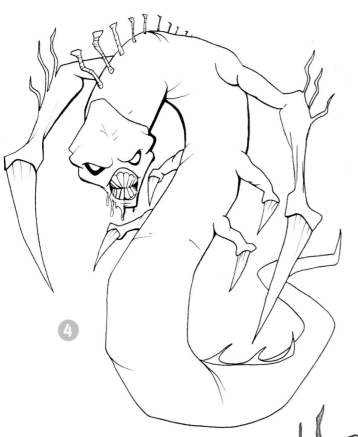

④

Add Finer Details

Small details have been added to give the monster some … ahem … personality. The drool adds a disgusting touch, and making one eye slightly larger than the other gives him a crazy "I can see you" look.

④ Ink the image and carefully erase the pencil lines to give the picture depth and form.

⑤ This monster is not only dangerous; it's unhygienic. The teeth and claws should never be white. Make them gross and yellowed with age, use and neglect.

Use lots of small hatching and cross-hatching lines so the light seems to fall across the form of the creature. Add a sense of realism to this unreal monstrosity with details such as arm muscle definition and an uneven claw surface.

A Dangerous Predator

The anatomy of this creature is definitely not human. It has a snakelike body and six arms.

This creature shares some of the same basic elements as the invader beast, but is an even sleeker and more dangerous predator.

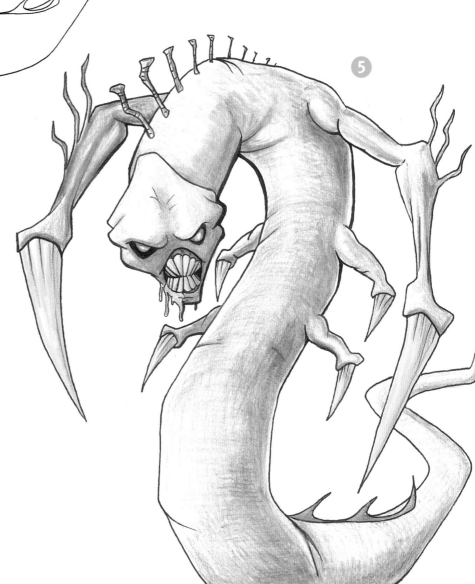

⑤

alien giant Robot

Invading aliens piloting giant robots have been a staple in science fiction since H.G. Wells wrote The *War of the Worlds* in 1898. Armed with the nastiest heat rays, laser cannons or missile batteries, giant robots are versatile weapons and vehicles rolled in one.

1 Block in the figure using sticks and circles. Make the legs very similar to those of the alien invader, with the addition of the tail to provide some balance. Make sure the limbs line up along the shoulders and hips.

2 Adding details over the construction lines will give you a better idea of the final product; however, there is still much work to do.

3 Clean up the original pencil lines and try to create a sense of the 3-D form of the robot. The weapon on the shoulder should look different from any human technology and appear, well, alien.

Alien Technology

When designing alien technology, inspiration can be found in the strangest places. The head of this robot was inspired by a triceratops skull in a museum and the plasma cannon was based on a fiddler crab's claw. The overall pose is similar to that of a gorilla and the tail structure was drawn after viewing the anatomy of a scorpion. The legs are based on a kangaroo and an ostrich. The result is something at once familiar, but ultimately unlike anything else on earth.

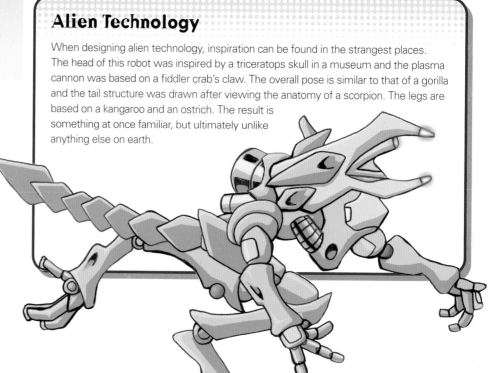

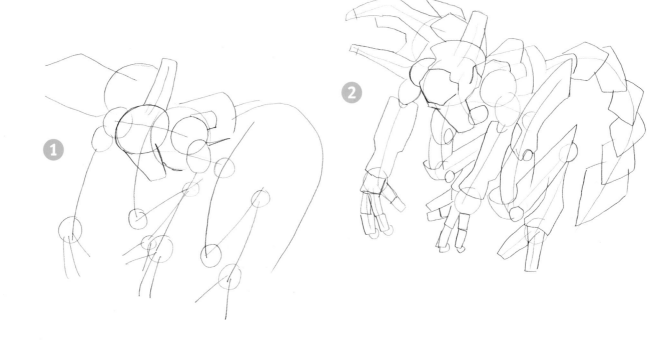

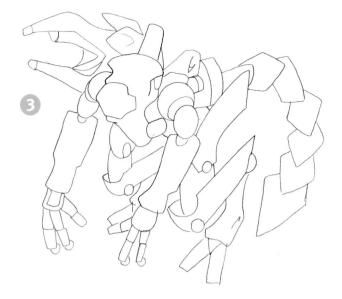

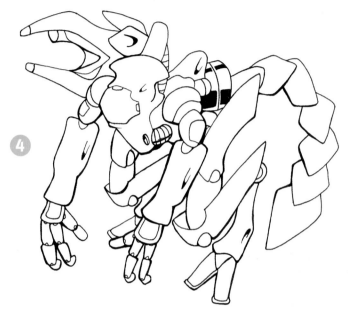

4 Ink with your black technical pen and erase the underlying pencil lines. The lines should vary in size from thick to thin to help describe mass and areas of shadow. Add large, dark shaded areas to simulate the reflective surface of the coolant tubes that connect the head to the torso and the engine exhaust on the robot's back.

5 When shading the robot, use the colored pencil to define the form, not just fill in areas with color. The legs and head, for example, should now appear 3-D and have a definite form and structure that wasn't obvious before.

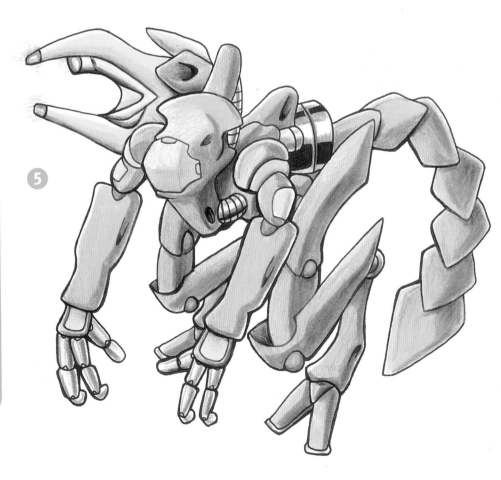

Definitely Not Human!

The anatomy of this robot is definitely not human. That large shape on the shoulder will be a powerful plasma cannon.

Remember to keep your technological "look" consistent as you draw your robot. This robot shares many visual design elements with the invader warrior's armor.

cosmic Warlord

*I*t's a big, bad universe out there, and there are those who will take advantage of the chaos and confusion to seize control. The cosmic warlord usually controls a sector of space and makes deals with all the major powers to remain independent. The cosmic warlord operates outside the law. He has gained power through illegal means and will do anything to keep it. Don't get on his bad side!

1 Block in the basic structure, remembering that a series of simple shapes put together creates a complex form. The pose should be strong and confident.

2 Ink the image to simplify the forms even further. Unlike the head, areas that are filled in with pure black appear flat and without highlights.

The bolts on his back might be part of an elaborate jet pack or they could provide power to his powered armor. Either way, they are simply four cylinders. Don't forget to draw them as 3-D forms. The symbol on his chest should be repeated on the armor of his lackeys, on the side of his starships and on banners in his throne room. Keep the design elements consistent and your imaginary world will seem real.

3 Make the colors bold and cartoon-like. This character is over the top and very flamboyant. He's powered up and looking for a fight!

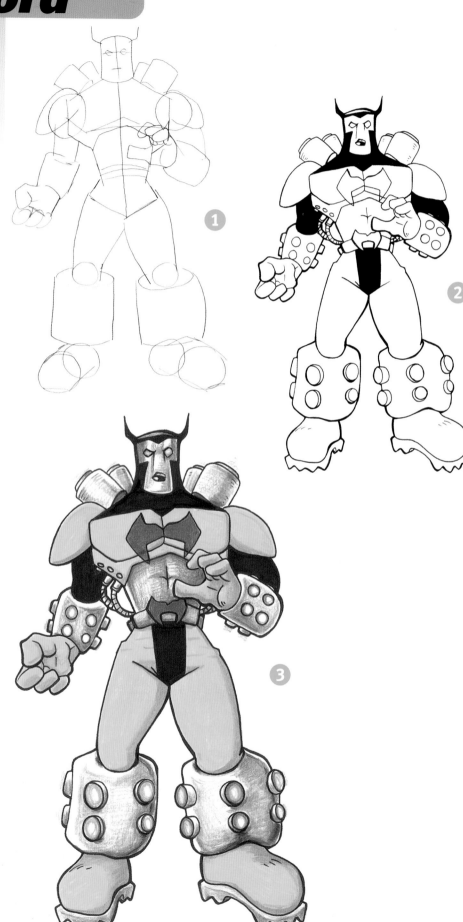

cosmic Pirate

Plying the spaceways are the suave and dashing galactic pirates. Wearing the Jolly Roger skull and crossbones with pride, they thumb their noses at authority and make their own rules. They are fierce fighters, but they are also incurable flirts and swashbucklers who are simply out for fun and profit rather than power or political gain.

1 Make the proportions long and lanky. The weapons should be exaggerated and almost playful.

　　The strange antennae and long neck give him an almost insect-like appearance. The flared pants and platform shoes are very retro, even for space.

2 Clean up the figure and add the necessary anatomical and costume details. Make the antennae curl at the end, just like a snail's antennae. Give him three fingers and a thumb to remind us that he isn't human and that the basic rules don't need to apply to aliens.

3 Make this galactic pirate exotic and sophisticated. He should appear very inhuman with his red eyes, blue hair and green skin.

　　The laser gun was inspired by pirate pistols of the eighteenth century.

killer **Robot**

Killer robots are designed for battle and come in all shapes and sizes. This robot has oversized, jet-propulsion boots that allow it to soar through the air. It also has a collection of vicious weapons tucked away within its access panels. With its set of powerful mini-missiles, this robot is armed and dangerous.

1 Block in the basic structure. This robot has a definite arch as it leans back, taking aim with the missile. One of the nice things about drawing robots is the fact that you can be creative with anatomy—pretty much anything goes with constructed creatures.

2 Add details such as the access panels and the wire "dreadlocks" to give the robot some believability and personality. Complete the wires that connect the torso to the waist, arms and head.

3 Carefully shade in the costume with colored pencil, designating areas of highlight, shadow and reflection, particularly on the silvery metal areas. Make sure you are not just "coloring in" your image but really drawing and shading 3-D forms. Look at reflective metal objects such as household appliances or even cutlery to see how light, shadow and reflection all interact on the surface.

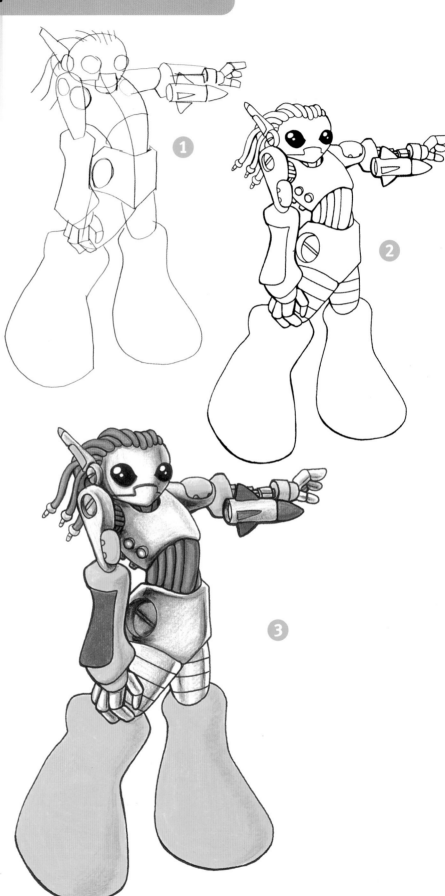

alien Pet

Sure it's cute and cuddly, but it's a dangerous fury of arms and fangs when it gets mad. An alien pet could be the sidekick of an adventurous spacefarer or a pest that won't go away. Look out! It's gnawing the hyper-warp drive wires again!

1 Use simple shapes such as spheres and tubes to block in the wee beastie. Make the proportions like those of a chibi, almost to the point of SD.

No matter how dangerous this creature ultimately may be, it should still look huggable.

2 Carefully draw the final lines in ink and erase the pencil work. It is important to remember to draw the guidelines lightly so they are easy to erase and to prevent impressions in the paper, which will make the coloring stage difficult.

3 Use this stage to add some details that are not readily obvious in the second step. By adding color you will separate the teeth from the fur (this wasn't immediately clear in the second step). Draw the shading and highlights on the fur so it appears coarse and unkempt. Shade and highlight the nose.

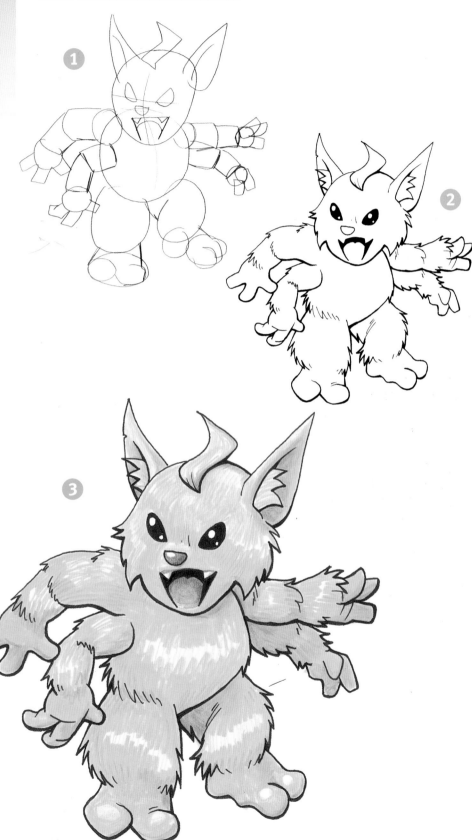

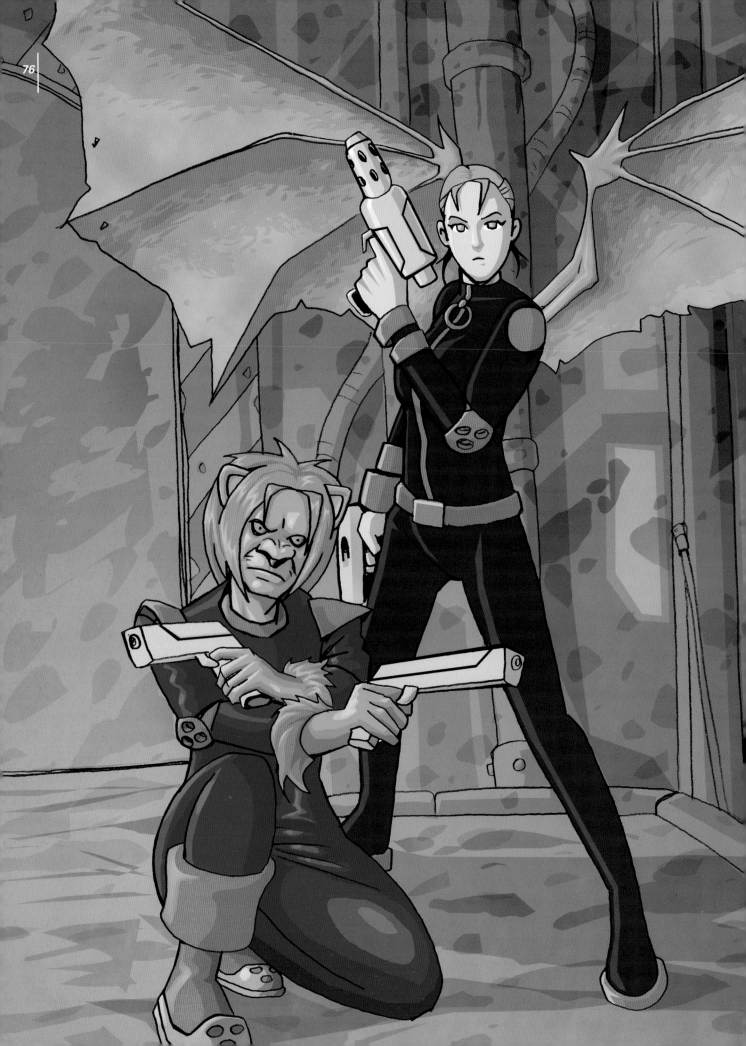

Mutants

One of the most common recurring themes in manga is alienation, or feeling different from everybody else. Mutants occur in all kinds of settings and genres. Some mutants have powerful mental abilities, while others have physically changed into something almost unrecognizable as human. Many mutant stories take place in a cyberpunk future where high-tech mutant warriors battle it out with other mutants and the forces of a corrupt government or megacorporation. Sometimes the mutant is a prophesied "chosen one," foretold to be born with special powers to lead their people to victory.

Understanding the basic structural elements and expectations of this genre will allow you to create something that exceeds—or goes against—the reader's expectations. Don't be afraid to try something different. Keep your stories fresh!

psychic Warrior

When this guy gets a headache, everyone gets a headache. Characters with amazing mental powers have appeared in manga for decades. Many of these psychic warriors must flee concerned government forces or even other psychics who use their powers for evil purposes.

When veins pop up from under the skin and blue energy begins arcing around his head, it's probably too late to run away.

1 Using sticks and circles, draw a pose that shows tension and force. Lean the body forward, almost off balance, as if every bit of mental and physical energy is being directed at the target.

2 Flesh out the character to reveal the intense concentration and effort required to use psychic powers. Make the face contorted in concentration. Make sure he is pushing forward onto the balls of his feet.

Psychic Abilities

So just what can different psychic warriors do anyway? Here is a list of ideas to help you create some of your own amazing mutants.

- **Pyrokinesis:** mental creation and control of flame
- **Telepathy:** speaking and listening with thoughts
- **Precognition:** sensing what will happen in the future
- **Retrocognition:** seeing what happened in the past
- **Clairvoyance:** seeing what is happening somewhere far away or seeing what can't be seen by normal people
- **Clairaudience:** hearing what can't be heard by normal people
- **Clairsentience:** the ability to feel sensations and emotions related to a place or event
- **Channelling:** communication with spirits of the deceased
- **Psychometry:** receiving information (visions, sounds or feelings) by touching an item
- **Healing:** repairing injury or illness with a touch

Reveal the Psychic Force

Showing how the surroundings are affected by the power of the character not only grounds the figure into a setting, but also reveals the level of force in his psychic abilities.

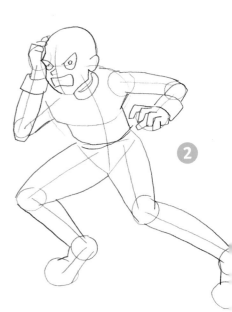

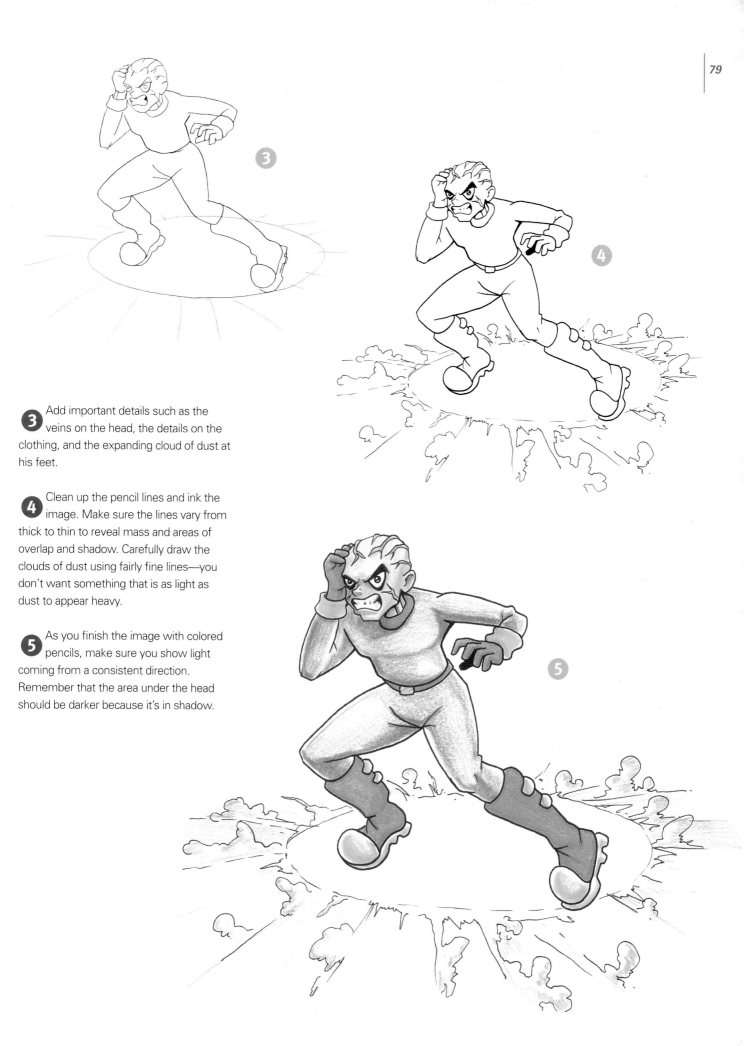

3 Add important details such as the veins on the head, the details on the clothing, and the expanding cloud of dust at his feet.

4 Clean up the pencil lines and ink the image. Make sure the lines vary from thick to thin to reveal mass and areas of overlap and shadow. Carefully draw the clouds of dust using fairly fine lines—you don't want something that is as light as dust to appear heavy.

5 As you finish the image with colored pencils, make sure you show light coming from a consistent direction. Remember that the area under the head should be darker because it's in shadow.

Cat Warrior

Cat/human hybrids are the most popular type of animal-based character in anime and manga. It's uncommon to find a catboy in manga (too tame), but a human that is spliced with the genes of a lion makes a powerful warrior.

1 Using sticks and circles, begin drawing the basic structure. Because the character is leaning forward, the head overlaps the chest and shoulders. The arms and the bent leg are foreshortened (drawn with shorter lines) to create dimension.

2 Block in the details of the character, making sure to maintain the fine balance between human and feline. Use the guidelines to maintain the proper anatomy and structure.

3 Erase the extra construction lines and fine-tune the details of the costume and figure. The image should be sleek and strong, just like a big cat.

4 Ink the image and erase the pencil lines carefully. It can be difficult to keep the drawing clear of extra lines, but it allows for you to shade carefully using colored pencil or the computer for the next stage. Little clues in your drawing, such as the highlight on the nose or the shadow on the barrel of the gun, reveal the direction of the light.

5 Use at least three shades of blue for the jumpsuit; blend them together using a white colored pencil. Use a darker blue to reinforce the shadows on the costume. The dark areas around his eyes keep light from reflecting into them to help him see better.

Genetic Mutations

Anthropomorphism refers to the condition when animals are given human characteristics. Japanese mythology has thousands of years of tradition in which animals act like humans, such as the tricky kitsune (fox people) or tanuki (raccoon-like dogs who like to dress up as monks).

With advances in genetic technology, it's possible that in some futuristic manga, humans might opt to splice themselves genetically with animals to become frighteningly powerful warriors. Such a character might also be the result of a failed experiment or medical procedure. Either way, the monstrous results would make for cool characters.

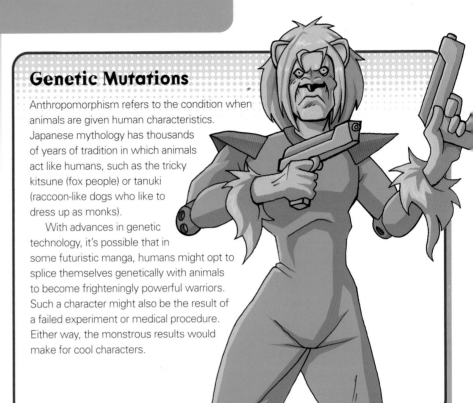

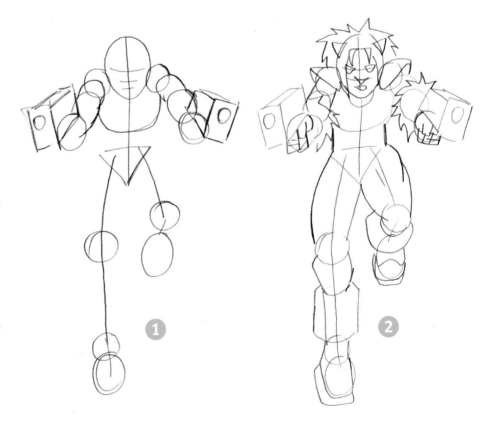

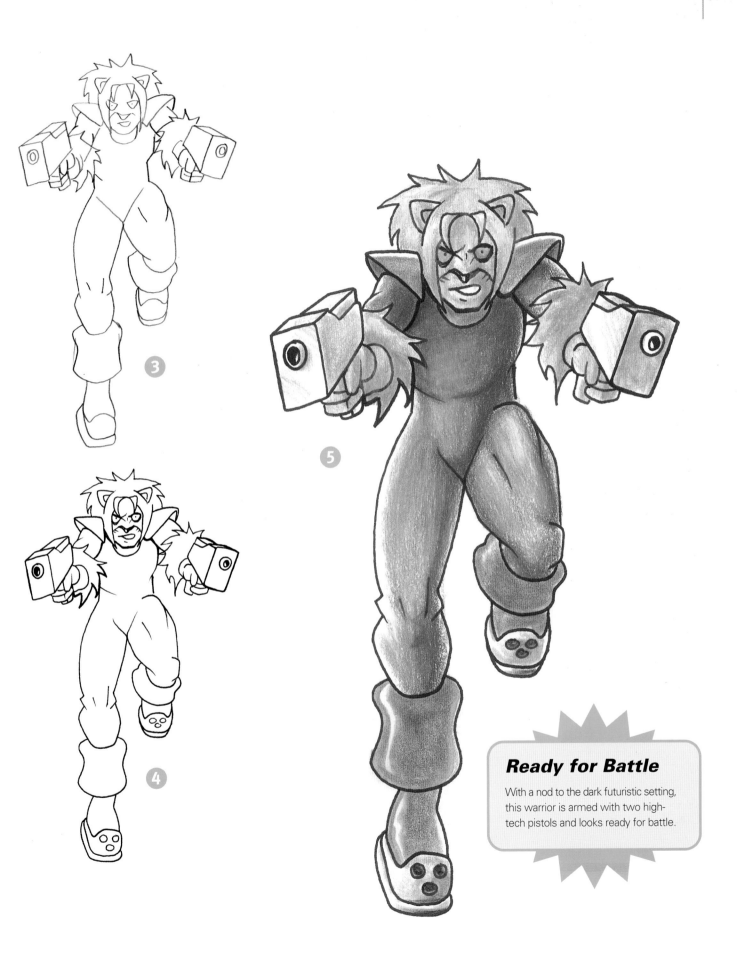

Ready for Battle

With a nod to the dark futuristic setting, this warrior is armed with two high-tech pistols and looks ready for battle.

Beast Man

The beast man is the result of genetic experimentation in an attempt to create the ultimate warrior. This guy looks like he's made from everything: goat, wolf, bat, ape, bear and lion.

1 With sticks and circles, draw the beast man hunched over in a very inhuman way, sniffing the air for a new target. Keep the proportions only vaguely human; include digitigrade legs and a tail.

2 Flesh out the details of the figure, blocking in its anatomy and weapon. Add the animal features at this stage.

3 Now the beast should begin to show a bit of character. He doesn't look particularly smart, but he does look dangerous.

4 Clean up the pencil lines and use ink to define the forms. Thick lines show what is in shadow and what is closer to the viewer.

5 Genetic tinkering apparently does weird things to fur coloration. The pale blue seems unnatural and manufactured, perfect for a genetically engineered clone warrior.

Send in the Clones

Manga and anime have used the idea of artificially created characters for decades. The idea of a steady stream of bad guys genetically engineered for mayhem is a scary thought. Clones in manga and anime usually are grown in tubes of mysterious fluid, and they age quickly. It's never really clear how the clones learn to talk or communicate, or how they learn basic skills like eating or following orders from their mad-scientist creators.

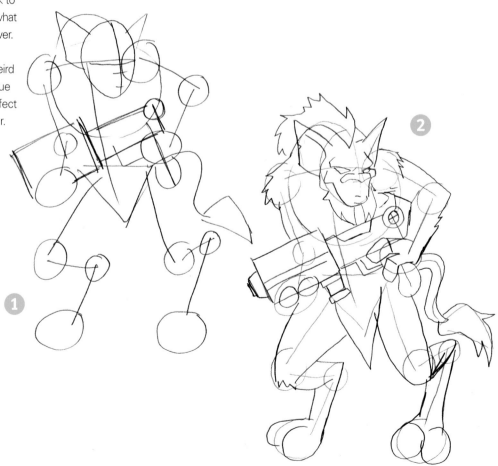

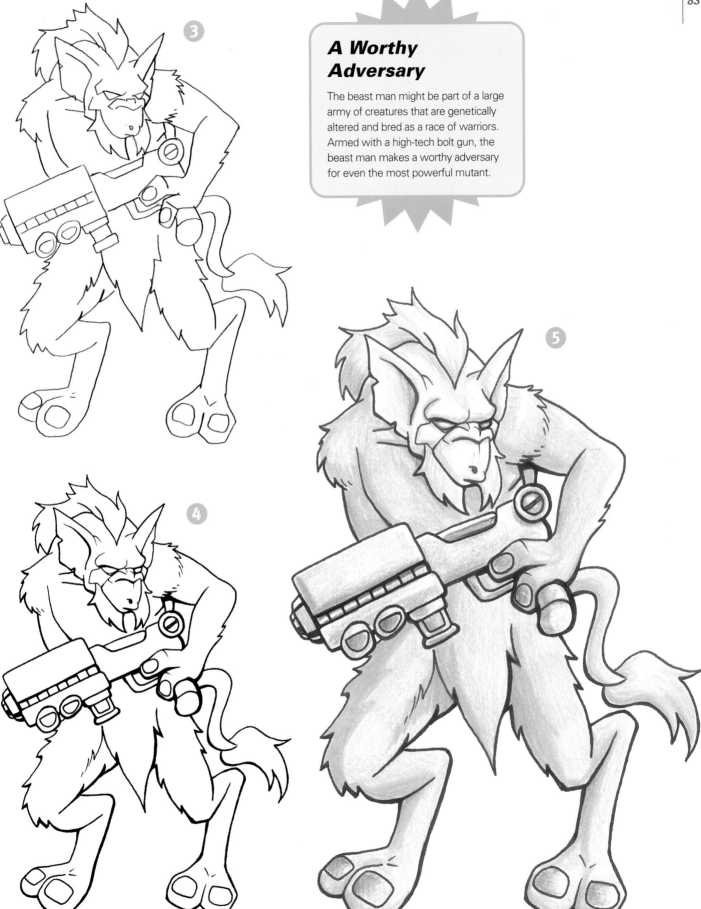

A Worthy Adversary

The beast man might be part of a large army of creatures that are genetically altered and bred as a race of warriors. Armed with a high-tech bolt gun, the beast man makes a worthy adversary for even the most powerful mutant.

bat-winged
Warrior

Bat wings are much more maneuverable than bird wings because they fold and unfold more easily. The bat-winged warrior's wings rise out of her back, at the top of the scapula just behind the shoulder joints. She uses her wings to get in and out of dangerous situations quickly and quietly.

1 Begin with the basic anatomy. Using sticks and circles, block in the elements as you go.

Notice the foreshortening of the pistol and the leg. Objects that are closer to the viewer will appear larger than those that are farther away.

2 Block in the anatomical details at this stage. Pay attention to the torque or twist of the figure as she rises into the air.

3 Clean up the preliminary pencil lines and start adding costume details.

This one-piece jumpsuit is fairly simple, but it requires you to focus on drawing the anatomy underneath it more precisely.

Wings and Things

Don't be afraid to play with the placement of the wings, even though the area behind the shoulders is the most common place to put them. Some manga and anime characters have alternate wing locations such as the hips. Some small wings on the temples, wrists and ankles could be very fashionable—although it would be hard for the character to get dressed. It may also be more logical to convert the arms into big wings; this would certainly be a more realistic use of muscle, bone and other tissue for a winged character.

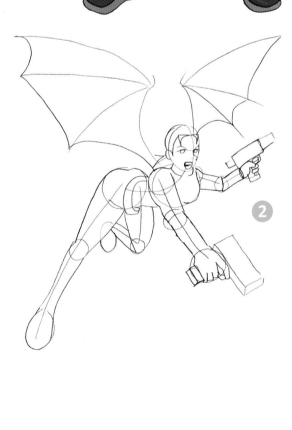

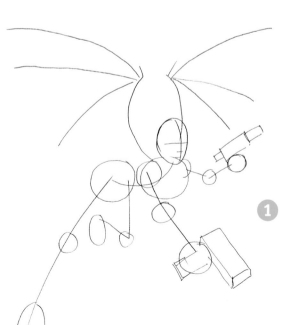

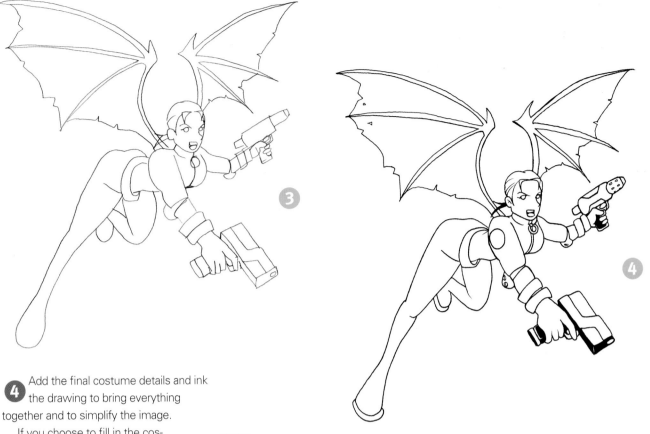

4 Add the final costume details and ink the drawing to bring everything together and to simplify the image.

If you choose to fill in the costume with black ink, you run the risk of flattening the image. Using colored pencil to draw the costume helps it appear 3-D.

5 Use the colored pencils carefully to really define the shapes. The wings are concave, so they have to be shaded to give the impression that they are catching the wind during flight. Because the costume is made from a shiny material, it will reflect light from various directions. Be sure it has a stronger area of highlight from the direction of the primary light source. Remember that strong highlights and dramatic shadows make objects like the pistols appear metallic.

Stretch the Bounds of Realism

You may want to research some real weapons for reference, but don't forget that this is science fiction; you can stretch the bounds of realism to make the guns look futuristic.

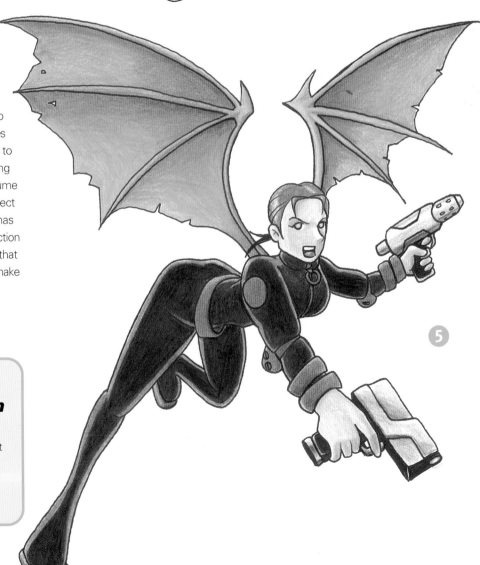

armored
Warrior

This character has just the right balance of cool and fun, one of the most refreshing qualities of anime and manga. The costume is high-tech and fairly boring, but the addition of the in-line skates offers a whole new perspective on who this character is and how he gets around. The flaming sword is high-tech and mysterious at the same time. The armored warrior is a young, cocky tough guy who uses the best equipment money can buy.

① Block in the basic anatomy with simple shapes.

② Block in the basic armor and equipment. Strive for a sense of movement and tension in the drawing.

③ Erase extra pencil lines and clean up the image so it is less confusing. Details such as the helmet, inline skates, armor and weapons should be blocked in carefully at this point.

Armor Galore

Heavily armored heroes battling terrifying mutant villains are classic elements of manga and anime. Powered armor is a nice source of heroic energy because the hero would be "normal" and almost helpless without his equipment. It is easier for readers to relate to a hero who isn't firing bolts of energy out of his head.

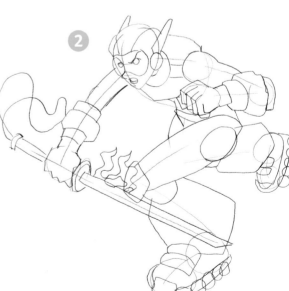

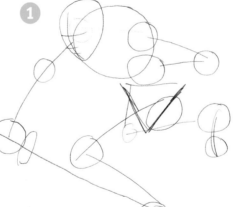

Shifting Weight

Look at people skating to understand how the weight shifts over the leg that is in contact with the ground for better balance and momentum.

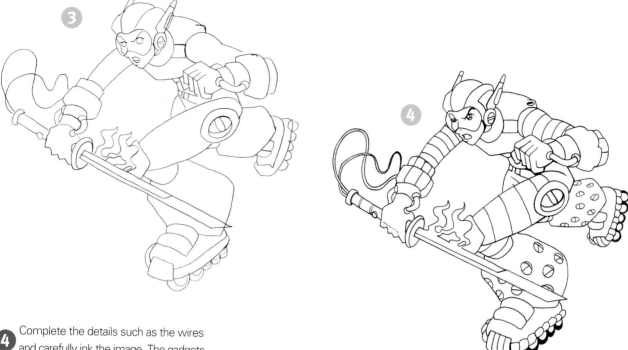

4 Complete the details such as the wires and carefully ink the image. The gadgets and technology may be a mystery to you, but wires, bolts, tubes and other accessories will make them look cool.

5 Carefully describe details and shapes using colored pencils. Notice how the shading on the metal includes areas of reflection and highlighting for a distinct metallic effect. Ensure rounded objects like the sword handle and the wires appear 3-D. The arc or energy on the power sword is carefully outlined in green and the middle is left white so it appears brightest and hottest. The green is then used as a highlight on the sword hilt as well as glowing over the standard blue of the knee pad.

Metal Man

This metal man is almost cute—but an army of these things would make an intimidating wall of unstoppable metal. Now that's something to think about!

1 Block in the metal man's anatomy with simple shapes.

The metal man's proportions don't have to be totally accurate because he is a robot, but don't make them too unrealistic or you will lose a level of believability.

2 Erase the under-drawing and add specific details.

3 Shade carefully with the colored pencil to make the image appear convincingly 3-D. Indicate reflected light and shading on the metal to make the drawing more realistic and believable.

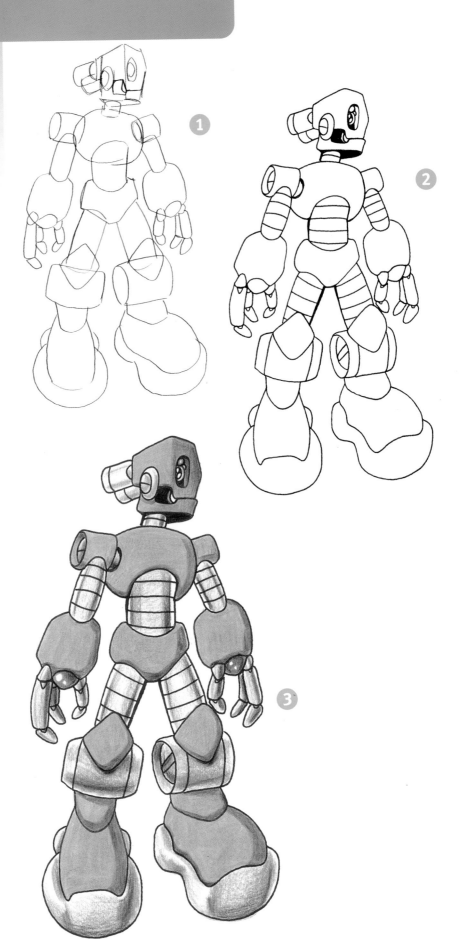

Merfolk

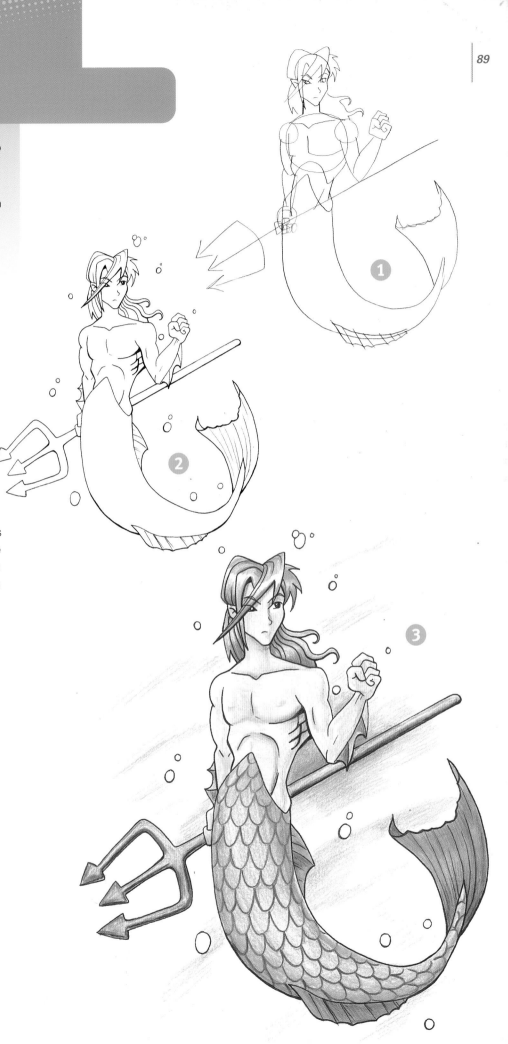

Merfolk are undersea mutants who are similar to the mythical mer-people believed to live deep below the surface of the ocean. Their combination of human and animal features could be a genetic trait or a medical experiment gone wrong.

1 Block in the anatomical details as you would with any other image. The fish tail can sweep back, forward or drop straight down. Angling it to the back creates a dynamic curve that moves the eyes around and back into the drawing, not away from it.

2 Remove extra pencil lines with an eraser and add fins, bubbles and other details. Make the trident (three-pointed spear) appear thick and heavy.

3 Shade everything with colored pencils to make it appear 3-D. Use two or more shades of the same color to give the image depth and range. Some details, such as the scales, are drawn totally in colored pencil. Adding such details at this final stage give more realistic texture to the drawing.

mutant Thug

A necessary evil of the dark, cyberpunk future are nameless armies of mutant thugs for the heroes to battle. A mutant thug should appear horrifically inhuman. This makes the character scarier and more unpredictable than something human. This example has tentacles for arms and unnaturally purple skin. Another mutant might have green skin, sharp claws and kangaroo feet. The possibilities are endless.

1 Keep the basic structure and anatomy of a normal human male, but add the tentacles. He's a mutant, so have fun. Create any combination of physical features that you can possibly imagine.

2 Erase the pencil work and add the anatomical and costume details. The bolts on the head and the glasses over the eyes remove even more humanity from his appearance.

3 Use clean and solid lines. Keep the direction of the light consistent as you shade the figure. Leaving areas of white gives a brighter highlight and makes the light appear stronger. Reflected light adds a sense of 3-D form to the figure.

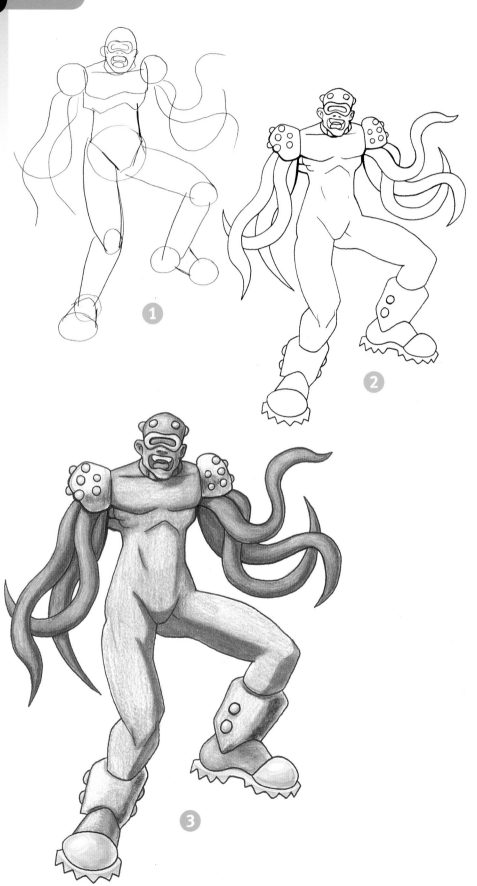

mutant Cyborg

Arising from the whims of nature and mad scientists, even ordinary mutants can be pretty intimidating. When you add high-tech cybernetics to the mix, you can get an even more formidable mutant. This cyborg seems almost indestructible.

1 Block in the basic anatomy. The basic proportions should be exaggerated and the addition of the massive shoulders and oversized boots will create a real monster.

2 Finalize the details and erase the pencil carefully. The cybernetic jaw gives this guy a robot-bulldog appearance. The surgery was not performed to win friends, but the results will certainly influence people—to run in terror!

3 Adding color allows the humanity of the flesh to contrast with the inhumanity of the metal. Burnish the metal surfaces with a white colored pencil to blend the colors so they appear smooth and reflective. Use strong highlights and reflections to add to the metallic look of the arms, jaw and legs.

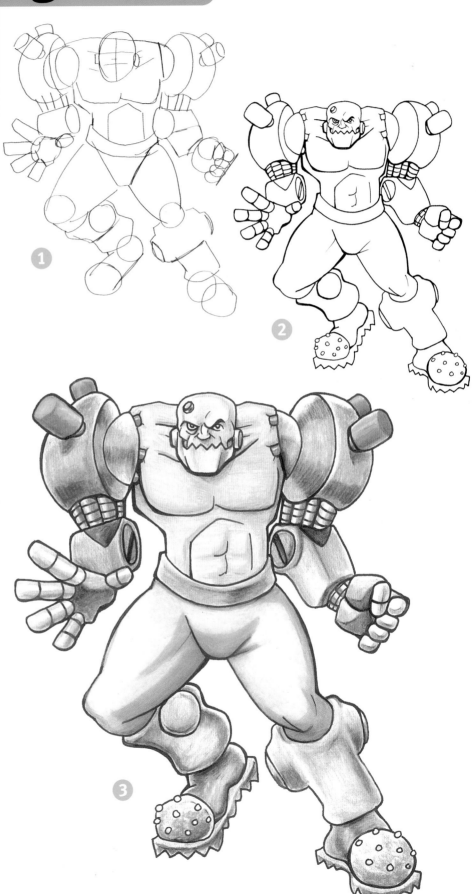

pet Monsters

The pet monster genre evolved from Japanese video and card games that pitted cute monsters against other cute monsters in gladiatorial combat. These monsters are usually paired up with children who challenge each other to duels of honor and glory. The children must hide their monsters from their parents, or else they must leave home on a personal quest of self-discovery and adventure. The youthful masters must win the trust and confidence of their pet monsters. Often the monsters gain new powers and get stronger as they grow or evolve. Little time is spent on developing the plot or character in this genre. The focus is on honor, friendship, loyalty and earthshaking monster combat.

The origin of the pet monster may be supernatural (legendary creatures), scientific (bioengineered warriors), alien (from other worlds or dimensions) or technological (computer-generated). The origin of the pet monster usually defines the look and feel of the manga. Some pet monster manga are serious while others are goofy, but almost all include comic relief villains who can never win. Pet monsters are usually very cute—and easily marketable as toys and action figures.

pet Rodent

Fighting pet monsters may be cute, but they often have surprisingly dangerous powers such as electric shocks, poison quills or hypnotic eyes. The pet rodent is cartoonlike and cute, like a plush toy.

The relationship between pet and owner is usually rocky until the owner learns to respect the power and independence of the pet. Eventually they become inseparable friends who mutually respect and care for one another.

1 Use basic shapes to loosely block in the anatomy of the monster. Make the head large and toylike. The pose should be active, energetic and fun. Make the proportions suit the nature of the character. Block in the details of the face and limbs. Keep the figure simple and uncomplicated.

2 Flesh out the details of the figure such as the fingers, toes, eyes and ears. The head is turned almost in full profile, as if the monster were looking over its shoulder and running from a bigger monster. The mouth is open in shock. Make sure the pose and the body language make sense before you move on. If you need to make changes, now is the time.

The Ideal Pet Monster

Small, round and always cheery, the pet rodent is the ideal pet monster.

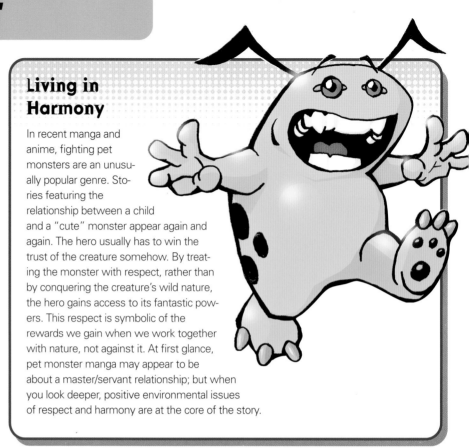

Living in Harmony

In recent manga and anime, fighting pet monsters are an unusually popular genre. Stories featuring the relationship between a child and a "cute" monster appear again and again. The hero usually has to win the trust of the creature somehow. By treating the monster with respect, rather than by conquering the creature's wild nature, the hero gains access to its fantastic powers. This respect is symbolic of the rewards we gain when we work together with nature, not against it. At first glance, pet monster manga may appear to be about a master/servant relationship; but when you look deeper, positive environmental issues of respect and harmony are at the core of the story.

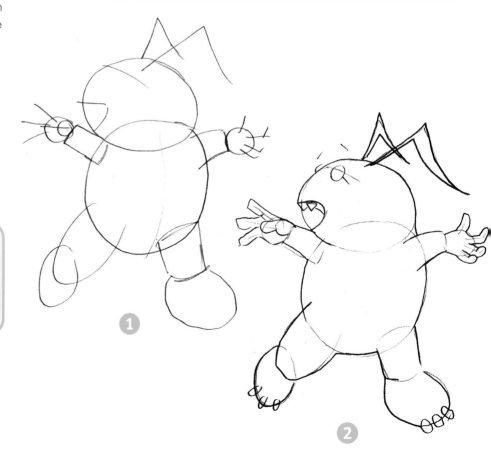

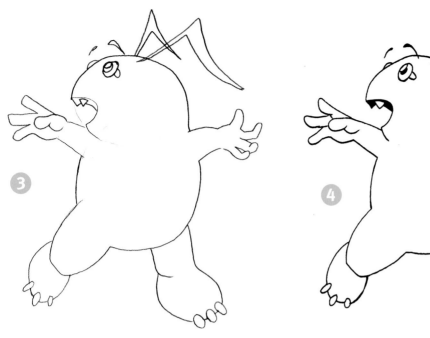

3 Clean up the construction lines and make the basic drawing clearer. Even though the proportions and details for this character are exaggerated and cartoonlike, don't be afraid to make some details, such as the toenails the hands, appear as 3-D as possible.

4 Decide on the details and make the lines simple and uncomplicated. Keep the sense of movement and fun in the character by not adding too much information.

5 Color and shade so the figure appears 3-D. Create rounded forms, not flat shapes. Add a sense of fun and excitement by using bright, crisp colors. Don't forget to include highlights to make the figure seem real—well, as real as a cartoon pet monster can be.

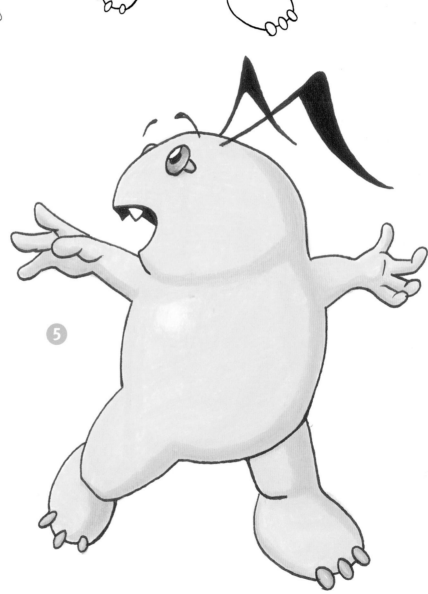

mini Dragon

Wouldn't you like a pet dragon of your very own? The mini dragon solves the problem of where to keep a giant, fire-breathing lizard. The mini dragon is usually the size of a cat or small dog. It can sit on your shoulder, curl up at the foot of your bed and generally look cute.

1 Use circles and sticks to indicate the anatomy of the dragon. The figure should be cute and pudgy. Keep the pose fun and playful. Don't include too much detail at this stage; just decide where everything belongs.

2 Add details to indicate the shape and structure of important features like the head, wings, claws and tail. The eyes should be closed and the tongue sticking out in a mischievous way. Keep the anatomy simple. This is not a genre that shows a lot of realistic detail.

3 Carefully erase the construction lines to clean up the drawing. Even though you are simplifying the forms, try to think of this creature as if it existed in 3-D space. Making the image too simple can flatten it. Use techniques such as overlapping the foot on the body and hiding a wing behind the neck to add a sense of dimension and realism to the pet dragon.

Dangerous Pets

In pet monster manga, there are usually very few "real world" problems related to owning a pet that is more dangerous than a tank. The pet's special powers may change or evolve in the course of a story. What might start out as simple fire breathing might develop into concentrated bursts of powerful fireballs or finely focused beams of heat energy. To make the character interesting, keep the idea of the power simple at first, then make it more complex later on.

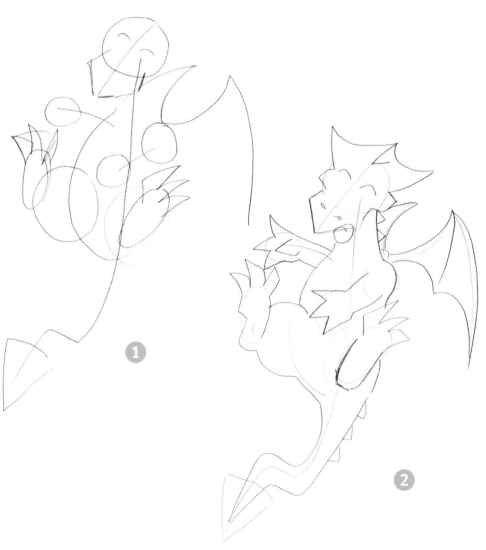

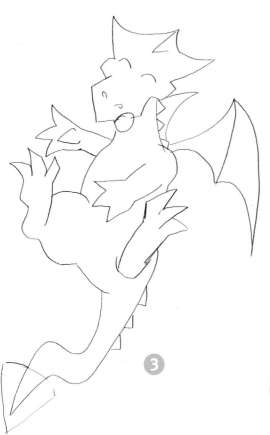

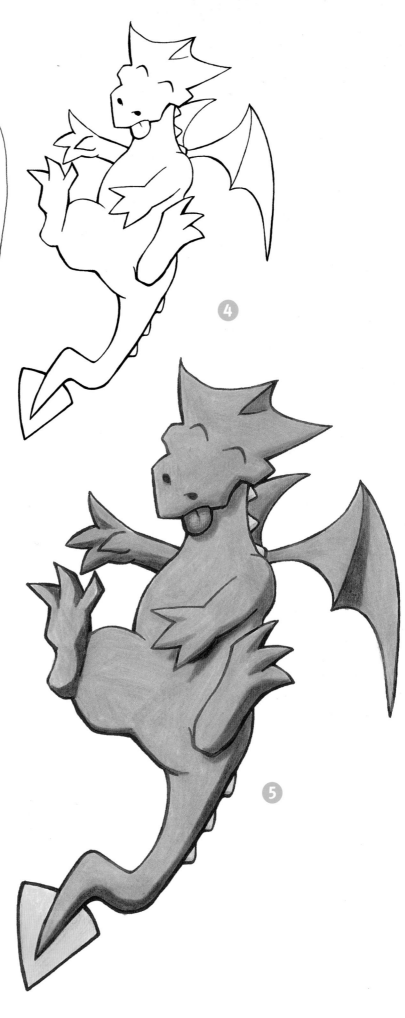

4 The final ink lines should be strong and crisp. Don't forget to vary the width of the lines for variety and to help describe the forms. The image has been pared down to the basics, but that doesn't mean that it's easy. You still have to know how the creature is put together to make it look "right." That's what step one is all about.

5 Add color and shading to give a 3-D appearance to the figure. Use rounded forms with areas of highlight and shadow. Avoid simply "coloring in" the image, which would make it look flat. Overall, keep it fun and playful.

Hidden Powers

As with the pet rodent, the adorable exterior hides the heart of a warrior beast with amazingly dangerous powers and abilities.

Monkey Fighter

The monkey fighter character appears in *The Monkey King*, a Chinese novel written by Cheng-en Wu in the sixteenth century. The Monkey King was a trickster who was an excellent magician as well as a powerful fighter. He could travel vast distances on the clouds, transform into many animals and was usually armed with an iron staff.

1 Start with basic circles and sticks. The proportions should be small and cute. The feet should be a bit bigger than human feet.

2 Start fleshing out the figure using your initial construction drawing as a guideline. Don't add too many details at this stage; just try to keep the proportions consistent.

3 Erase the original pencil lines and add details such as clothing and jewelry. The shirt and pants have a sort of Chinese style. Hair on the head and on the body is simplified and stylized.

Inspired Success

The adventures of the Monkey King were the inspiration for the Dragonball manga by Akira Toriyama and several anime and video games.

The Trickster Tradition

Japanese mythology has its share of shape-shifting tricksters. Two mischievous and sometimes tragic creatures are the kitsune and the tanuki.

The kitsune is a magical fox that leads people astray with fox-fire. Kitsune may be over one-thousand years old and can appear as silver or white foxes with nine tails. The kitsune also can transform into beautiful maidens, and they have a dark side, misleading people at night and sometimes possessing women, causing them to behave strangely.

The tanuki is a raccoon-like dog native to Japan and parts of Eastern Asia. Tanuki were considered to be magical shape-shifters who particularly enjoyed appearing as monks or tea kettles to play tricks on people. Tanuki are considered comical and lucky, and statues of them are often used to welcome people into restaurants.

1

2

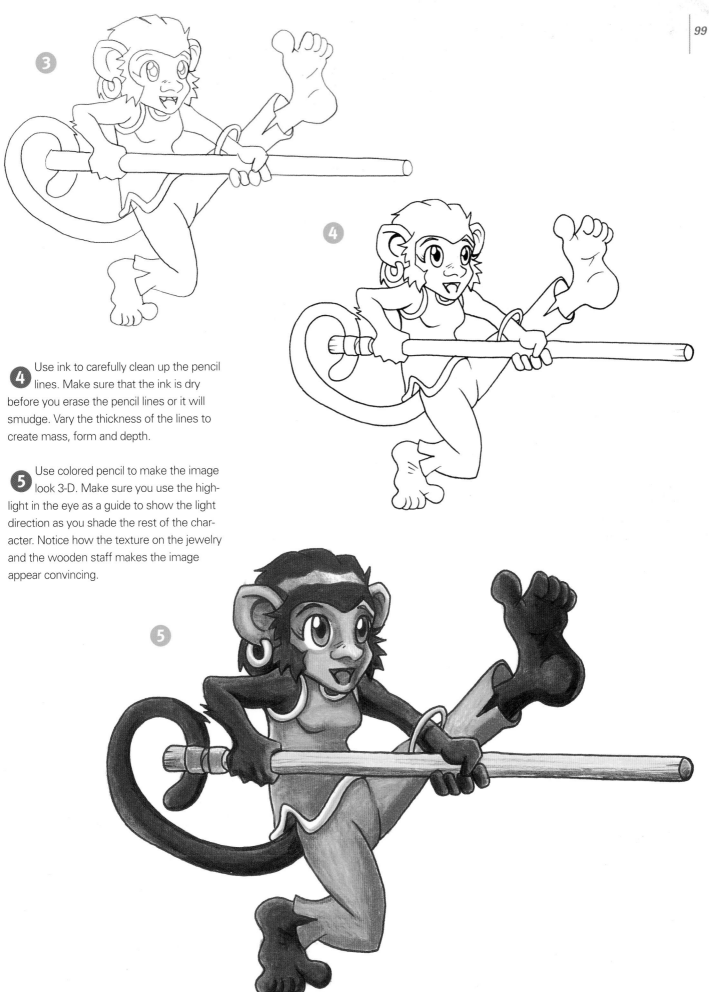

4 Use ink to carefully clean up the pencil lines. Make sure that the ink is dry before you erase the pencil lines or it will smudge. Vary the thickness of the lines to create mass, form and depth.

5 Use colored pencil to make the image look 3-D. Make sure you use the highlight in the eye as a guide to show the light direction as you shade the rest of the character. Notice how the texture on the jewelry and the wooden staff makes the image appear convincing.

Cabbit Mascot

The "cabbit" is a peculiar creature common in manga and anime that appears to be a combination of a cat and a rabbit. It usually is used as a sidekick or mascot character that serves no purpose other than to look cute on cue. It stops grooming itself momentarily to look at what the hero is doing, and when things look really bad it transforms into a powerful weapon.

1 The proportions that you block in should be all about making the character look cute. Keep the lines loose and fun.

2 Use the guidelines to develop the basics of the character. Make the eyes supersized, almost half the size of the face. Details of the fur should be suggested simply, with jagged lines to indicate the growth direction. Don't draw every hair.

3 Erase your rough pencil lines and generally clean up the image. This will make inking easier and let you solve any problems before you commit the drawing to a more permanent medium.

Supersized Eyes

The eyes of the cabbit should be supersized, almost half of the size of the face. Just remember: The larger the eyes, the cuter the cabbit!

Kawaii!

Kawaii (kah-wah-ee) means cute in Japanese. It is one of the most commonly used words in Japanese pop culture. Cute images appear on everything from pens and paper sets to phone cards and handbags. The origin of this obsession with cute characters and childlike imagery was probably a trend in the early 1970s called burikko-ji or "fake-child writing." Teenage girls in Japan began using a childishly cute handwriting style. This new style irritated adults because it was hard to read, and it became so pervasive that it was banned from schools. Cute culture spread from an underground handwriting movement to fashion and design. In some ways it's an attempt to regain a childlike innocence or sense of fun. Kawaii characters are familiar, cozy and happy—that's the secret of their success and widespread use by corporations. Today the culture of cuteness is a huge business, with Sanrio (creators of Hello Kitty) earning billions of dollars on their kawaii kitten.

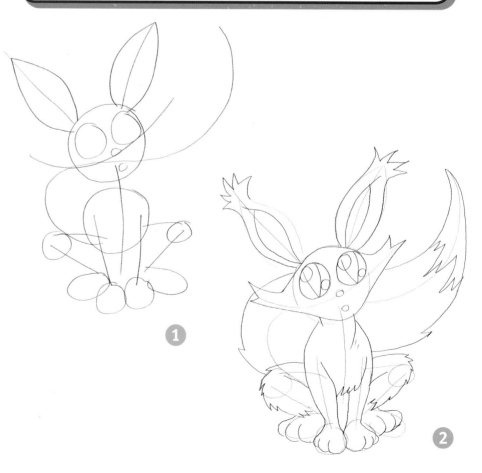

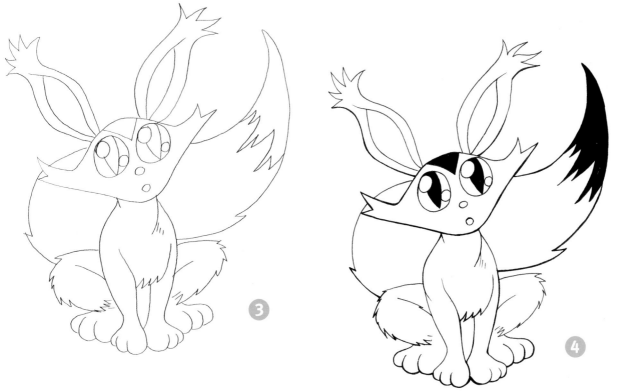

4 Some areas are totally filled in with ink. This can flatten the final drawing, so you will have to be very sure your colored pencil work develops form and roundness. Keep your ink lines fluid and vary their width. Thick lines show areas of shadow and weight.

5 For the main colors, use terracotta earth tones and a reddish pink. These colors really contrast with and draw attention to the bright, green eyes. Notice how the areas of shadow and highlight on the fur are blocked in and darker than the more neutral fur color. This "cell-shaded" technique is meant to mimic techniques used in classical animation.

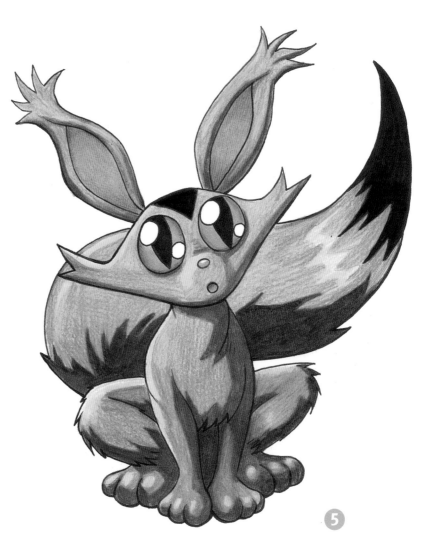

Robot Mascot

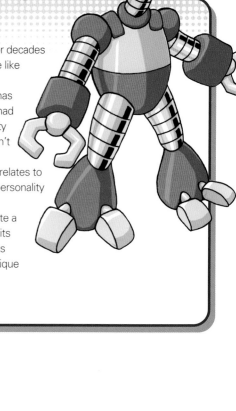

Robots can be cute, too. The robot mascot is not particularly high-tech looking. He seems to be a helpful assistant, not some city-smashing monster.

1 Keep the structure simple. Make the proportions like those of a cute chibi. Make the eyes huge and give the mouth a slight smile. The robot should appear harmless.

2 Make the mouth hinged to give the face a goofy grin. Make the rest of the body rounded with almost chubby features. This robot is looking very cute!

3 Clean up the pencil lines and define the details of the body. Add claws instead of fingers to give a retro appearance to the figure. The lightbulb on the head should be like the idea bulb on an old 1950s futuristic robot. This retro look gives him charm and timelessness.

Cute Robots

Japanese corporations have been working for decades on creating robots that can move and behave like human beings.

Honda's Asimo is a humanoid robot that has appeared in television commercials and has had much media coverage. It is notable for its ability to move in a very humanlike fashion, but it isn't available for consumers yet.

Sony's Aibo is an adorable robot dog that relates to its environment, developing its own unique personality as it learns.

Sony's SDR-4X is another attempt to create a consumer robot that observes and adapts to its surroundings. It walks as a biped and interacts independently with humans, developing a unique identity different from any other SDR-4X.

Comic Relief

Robot mascots usually provide comic relief in a manga and often are more trouble than they are worth; they are likely to jettison luggage into space or press the wrong button at the worst possible time. When the robot mascot is really needed, however, it can usually be counted on to do the job.

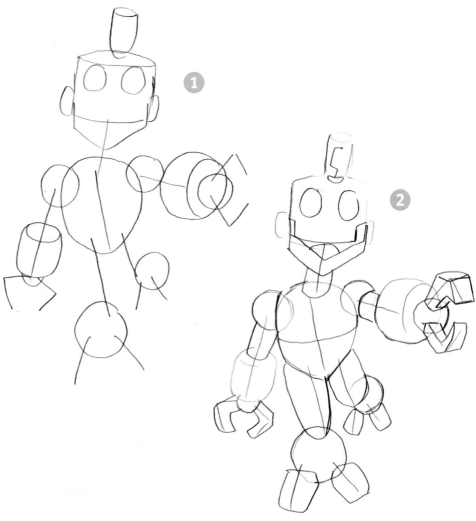

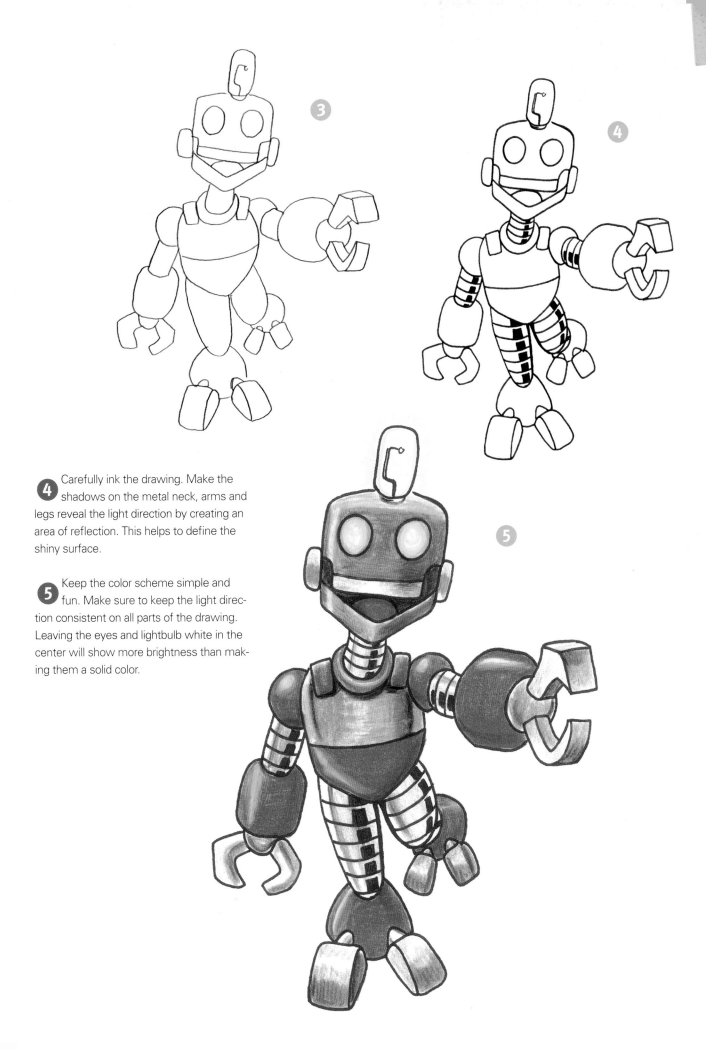

4 Carefully ink the drawing. Make the shadows on the metal neck, arms and legs reveal the light direction by creating an area of reflection. This helps to define the shiny surface.

5 Keep the color scheme simple and fun. Make sure to keep the light direction consistent on all parts of the drawing. Leaving the eyes and lightbulb white in the center will show more brightness than making them a solid color.

snow Beastie

From the far reaches of the arctic comes the abominable snow beastie. The hat and mittens on the furry body are an attempt to make the snow beastie appear like a cross between a yeti and a child's snowman. Even though he has powerful tusks, keep him jolly and good-natured looking.

1 Make the proportions short and cute for this cuddly monster. Carefully sketch in the details such as the hat and teeth.

2 Cover the hands in mitts that are too big for the monster. Make the hair scruffy and fuzzy. Make the hat look old and worn out. He should look like a laughing snowman.

3 Carefully shade the monster, trying to reveal 3-D form with areas of shadow and highlight. Choose blue for the fur because it is a "cool" color and will reinforce the "abominable snowman" theme for the character. Everything else should stand out and be vibrant.

Orb Critter

Many fighting monsters appear as simple spheres. The trick to making them interesting is to accessorize them to give them unique personalities. Sometimes the orb critter is a young version of a pet monster (a walking, talking egg).

1 There's no real trick to this one, folks. Draw a circle, add a face, two feather tufts and some feet. Create interest by making the character run.

2 Define the form a bit more and erase the rough pencil lines after you finish the sketching. Ink carefully to create a pristine, snappy drawing that shows everything as clearly as possible.

3 Avoid the temptation to simply "color in" this basic form, which would then appear way too flat. Highlights and shadows keep the orb critter rolling.

little **Spirits**

Little spirits tend to travel in swarms that fly around, causing mischief and misery to those who get in their way. They love to take complex things like machines apart and hide objects like keys or important papers when they are most needed. Little spirits are grumpy—so stay out of their way!

1 Draw a simple, cartoonlike structure. Don't go into too much detail at this stage; just indicate where everything is going to go so you can finish the image later.

2 Spirits need few details or adornments. Make the arms and legs simple and flat black. Make sure the stripes have high-lights showing where the lightest area on the bug-winged creature should be. Make one eye narrower so it looks as if it were squinting in a suspicious way.

3 Keep the coloring simple. Use two shades of purple for the skin. The light direction determines where the areas of light and dark fall. Keep the wings light and transparent. Make this guy look like a very grumpy bug.

Elementals

The four elements—water, fire, earth and air—are spirits of the earth that can be controlled by powerful magicians to do their bidding. The elementals are actually four monsters who could do a lot of damage if they got out of control. Water would flood things, fire would burn things, earth could cause a landslide and air might lift the roof off the house.

1 Block in the basic shapes of the elements. Keep the level of detail down to a minimum at this stage. If you make an error, you don't want to have to redraw everything.

2 Have fun inking these guys. Make the lines vary in thickness so some parts stand out and others recede. Erase your pencil lines and remember that you are trying to depict what these monsters look like as 3-D forms no matter how cute or simplified they are.

3 The color choices are going to be pretty obvious and related to the element at hand. Keep in mind that the 3-D forms should be fairly organic and fluid. The eyes should glow, revealing their supernatural origins.

Supernatural
beings

There are several "classic" monsters in Western pop culture. Monsters such as Frankenstein or Dracula appeared in nineteenth-century novels and later as twentieth-century films. Authors, artists and filmmakers have reinvented these monsters time and again, making them relevant for each new generation. Although Japanese culture has its own tradition of supernatural beings, it is always fascinating to see how Western monsters are interpreted in manga and anime.

Supernatural beings are the basis of many modern horror stories and when many of us think of monsters, these are the creatures that spring to mind. Supernatural anime and manga stories are often set in the modern era, in recognizable urban settings. This combination of the strange and the familiar adds to the sense of unease and horror.

Manga and anime creators always try to keep the audience wondering what will happen next and questioning just who the good guys and the bad guys are. By toying with our expectations, they often create something uniquely horrifying.

Angel

The angel, or tenshi, is a winged being believed to be the messenger of a divine being. Glorious and powerful, the angel battles evil to protect humanity. Angelic characters are quite common in anime and manga. They are usually female and there are usually countless loose feathers floating around them. If they really lost that many feathers, they wouldn't have any left on their wings—but it's still fun to draw all those flying feathers.

On a Wing and a Prayer

Tenshi literally means "son of heaven" in Japanese. It can refer not only to angels but to the emperor of Japan, who is supposed to be descended from divine beings.

The tennin is an otherworldly, attractive person (usually female) who is robed in feathers. She appears on mountaintops to greet pilgrims who are on a spiritual journey.

1. Start with the same basic circles and sticks that you use for everything else you draw. Block in the figure considering the anatomy, pose and action of the character. The wings don't have to be overly detailed at this time; just block in where they should be located.

2. Put some meat on that turkey! Add the details of the figure, such as the feet, hands and wings, then block in the basics of the costume and props.

3. Clean up your initial pencil lines and reinforce the anatomy and details.

4. Carefully ink your drawing and then erase the pencil lines. So you don't smudge the ink, let it dry completely and make sure you have a clean eraser. (Using permanent ink in the first place will prevent most smudging.)

5. Use colored pencils as an opportunity to provide more dimensionality to the form rather than just coloring it in. Be aware of the direction of the light and make sure your shadows and highlights relate to it. Pay attention to the highlights on the hair and the pistol as well as the reflected light on the skin and clothing.

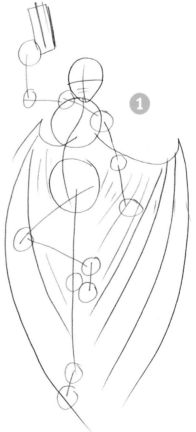

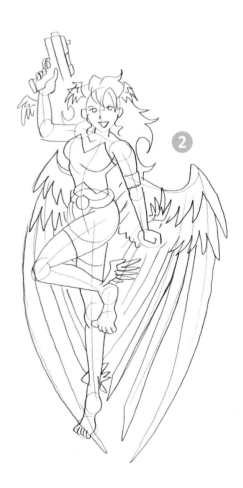

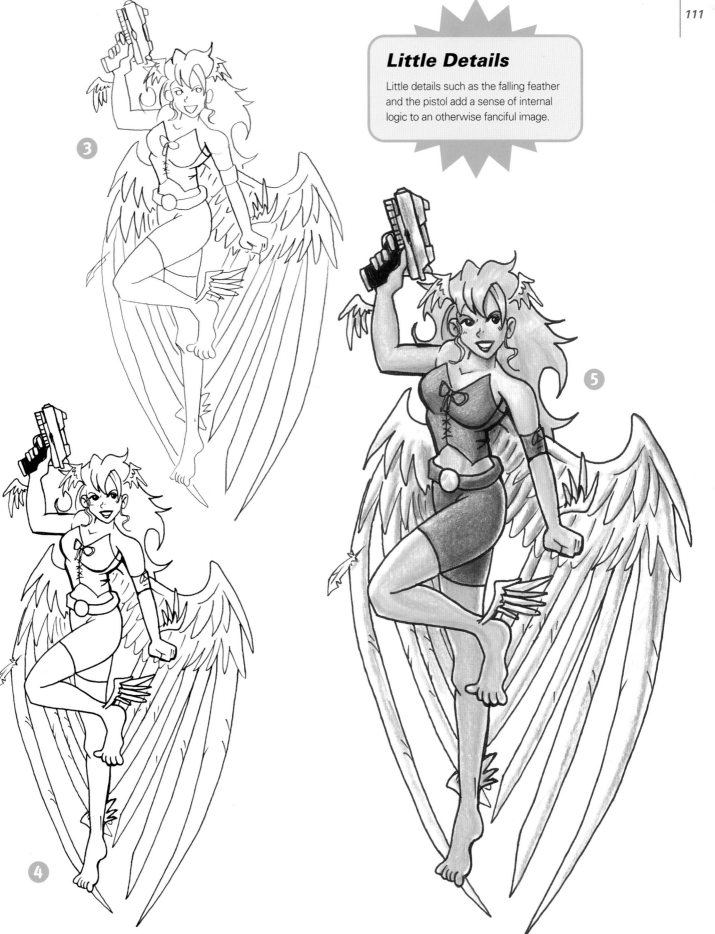

3

Little Details

Little details such as the falling feather and the pistol add a sense of internal logic to an otherwise fanciful image.

5

4

Demon

The demon is usually considered a creature of evil and darkness, often more tricky than powerful. In Japan, the legends of the oni (Buddhist demons) reveal a more complicated approach to personifications of evil. Some oni are even depicted as itinerant priests, a symbolic parody of humanity's failings. Manga and anime have used oni as adversaries for heroes and as the inspiration for many heroic characters.

This demon is drawn in the classic Halloween demon tradition, with red skin and a pointed tail.

1 The basic structure should be strong, with a wide leg base. The demon's hand is raised and will be glowing with fire. Make his tail pointy to reinforce the devilish nature of the character.

2 Loosely block in the basic 3-D structure. Remember that the arms and legs should be cylindrical, not flat. Details such as the hands and some facial features should be developed at this stage.

3 Erase unnecessary guidelines and structure references. Add the fire special effects and clothing details.

Demonic Oni

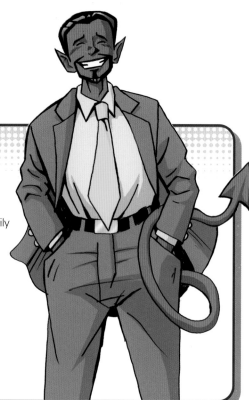

In Japanese Buddhist tradition, oni are supernatural creatures that travel between the land of the living and the land of the dead. They are not necessarily wicked, but are wild forces of nature that often bring bad fortune to whatever unfortunate soul gets in their way. Sometimes, however, they may bring good fortune.

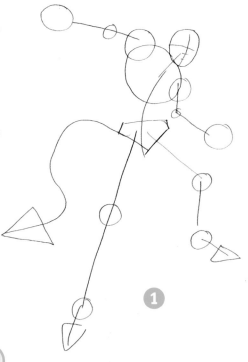

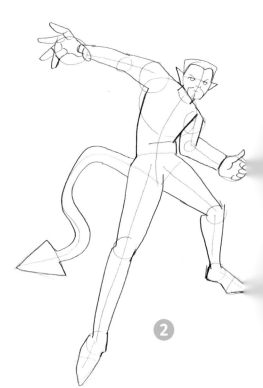

Trying to Fit In

The suit and tie may seem odd at first, but they show how the demon is trying to appear "professional" to fit in with the modern world.

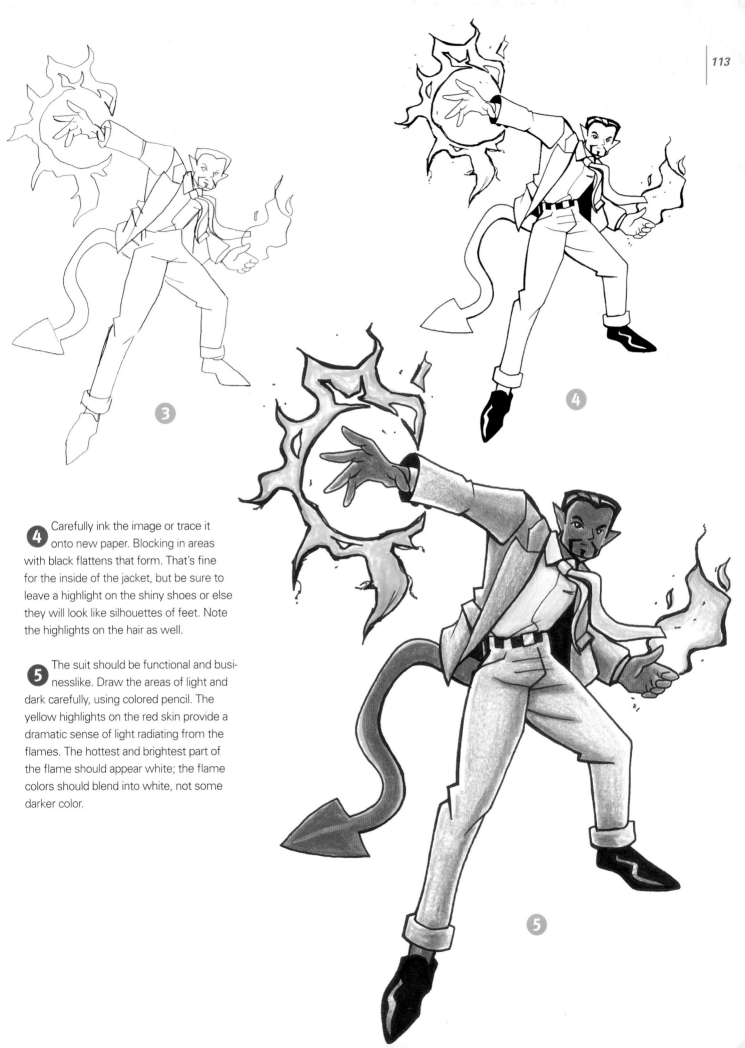

4 Carefully ink the image or trace it onto new paper. Blocking in areas with black flattens that form. That's fine for the inside of the jacket, but be sure to leave a highlight on the shiny shoes or else they will look like silhouettes of feet. Note the highlights on the hair as well.

5 The suit should be functional and businesslike. Draw the areas of light and dark carefully, using colored pencil. The yellow highlights on the red skin provide a dramatic sense of light radiating from the flames. The hottest and brightest part of the flame should appear white; the flame colors should blend into white, not some darker color.

Vampire

*T*he vampire depicted here wears a costume similar to clothing worn by eighteenth-century nobility. Vampires are immortals who must suck the blood of humans to maintain their youth and power.

In anime and manga, vampires sometimes have been depicted as the heroes of the story, battling others of their own kind to punish the wicked and preserve humanity.

1 At this stage, block in the anatomy just as you would any other image.

2 The leathery skin on the bat wing creates a very specific shape where it joins the finger bones in the wing. Make sure you include that shape when drawing the wing. Make the vampire seem even more "realistic" with correct anatomy and costume details. Make the claws of the vampire look dangerously sharp.

Two Distinct Elements

This image is unusual because it has two distinct elements: the bat and the vampire. Classic vampire mythology states that vampires can transform into animals such as wolves and bats.

Vampires of the East

The vampire legend, as personified by Dracula in Western literature, most likely originated in China. It was believed that everyone had two souls, a rational soul and an irrational soul (p'ai). The p'ai could preserve and even animate a body, especially if the death had been violent or there was an improper burial (or no burial at all). Some legends state that even if a cat jumped over a dead body, it would turn into a vampire.

The chiang-shih vampires of China had terrible fangs and fierce claws. Their hair grew long and white, and they could change into wolves. One major weakness of the chiang-shih was that if they came upon spilled rice or seeds, they would have to stop and count each grain before continuing. They were also afraid of garlic and salt. They could be chased to their resting places with a broom. The only sure way to destroy a chiang-shih was with fire.

The Japanese vampire is a kyuuketsuki. This vampire may have been buried in cursed earth, or it may have died without breathing its final breath. Kyuuketsuki usually preyed upon members of their own family.

There is also a legend of a Japanese vampire cat known as O Toyo that had the ability to transform into a human woman. O Toyo made the royal guards fall asleep and drank the blood of the Prince of Hizen. She was eventually hunted down and destroyed.

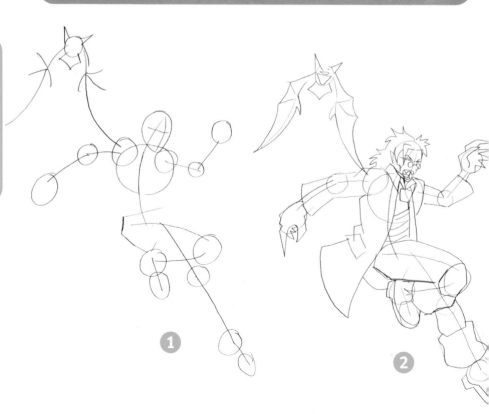

1

2

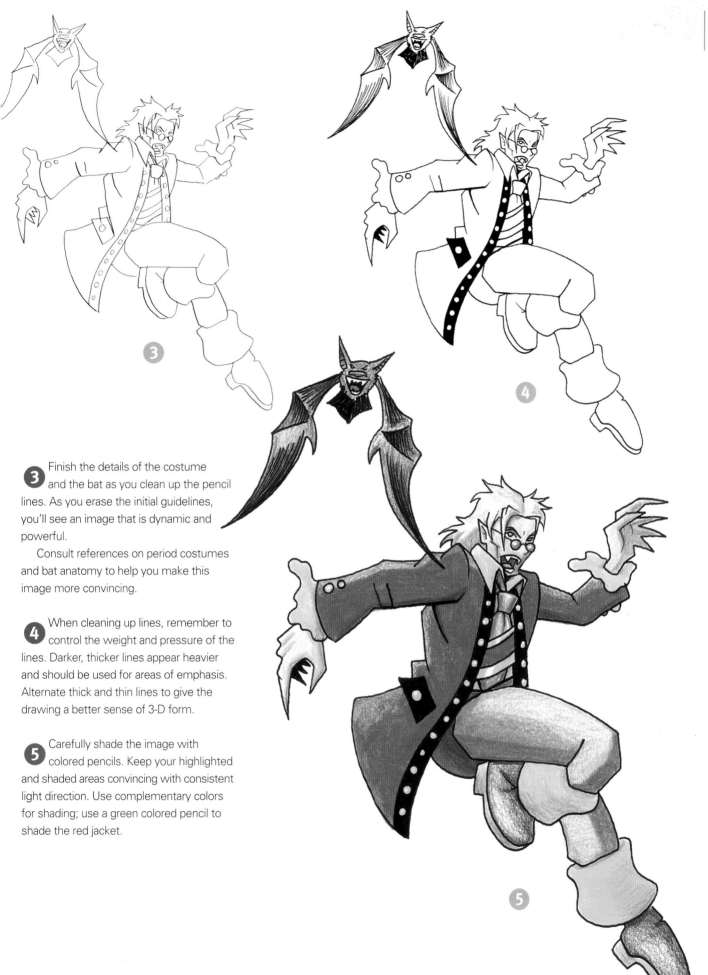

3 Finish the details of the costume and the bat as you clean up the pencil lines. As you erase the initial guidelines, you'll see an image that is dynamic and powerful.

Consult references on period costumes and bat anatomy to help you make this image more convincing.

4 When cleaning up lines, remember to control the weight and pressure of the lines. Darker, thicker lines appear heavier and should be used for areas of emphasis. Alternate thick and thin lines to give the drawing a better sense of 3-D form.

5 Carefully shade the image with colored pencils. Keep your highlighted and shaded areas convincing with consistent light direction. Use complementary colors for shading; use a green colored pencil to shade the red jacket.

Werewolf

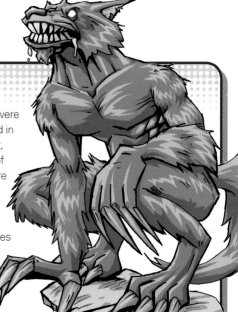

*O*ne of the classic monsters of legend, literature and film, the werewolf is a cursed human who transforms into a monster during the full moon. Japanese mythology is full of transforming creatures. However, these are usually animals that turn into humans, not vice versa. The legend of the werewolf seems to have come from Norse myths of berserk warriors totally losing themselves to an animal nature, or the Greek myth of Lycaon, who was transformed into a wolf by Zeus.

The werewolf should be a hairy, half-human beast with terrible claws and sharp teeth.

Crying Wolf

Considered rabid and dangerous, wolves were systematically hunted down and destroyed in Europe during the middle ages. As a result, wolves are virtually extinct in some parts of Europe today. North American wolves were also hunted.

Wild wolves generally like to keep their distance from humans, but although attacks on humans are rare, they sometimes occur when food is scarce.

The slow, horrifying death from the rabies often associated with wolves may be the origin of some werewolf myths.

1 Draw a front-on view of the werewolf in a crouched position. This stance represents a direct, aggressive threat that would scare the werewolf's victim. Keep the lines light so they are easier to erase later on.

2 Block in the structure, including details such as the hair, claws and wolf-like face. Make the claws on the hands and feet huge. Give the werewolf a large tail and a stance that distributes his weight efficiently.

Preliminary Structure

No matter how inhuman the monster is, the final image always benefits from preliminary anatomical structuring.

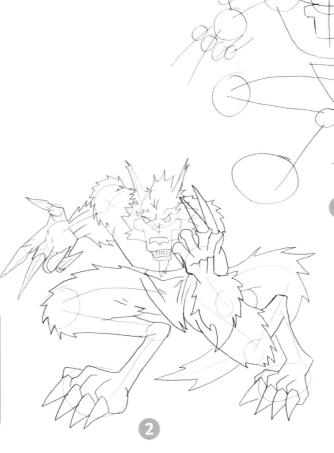

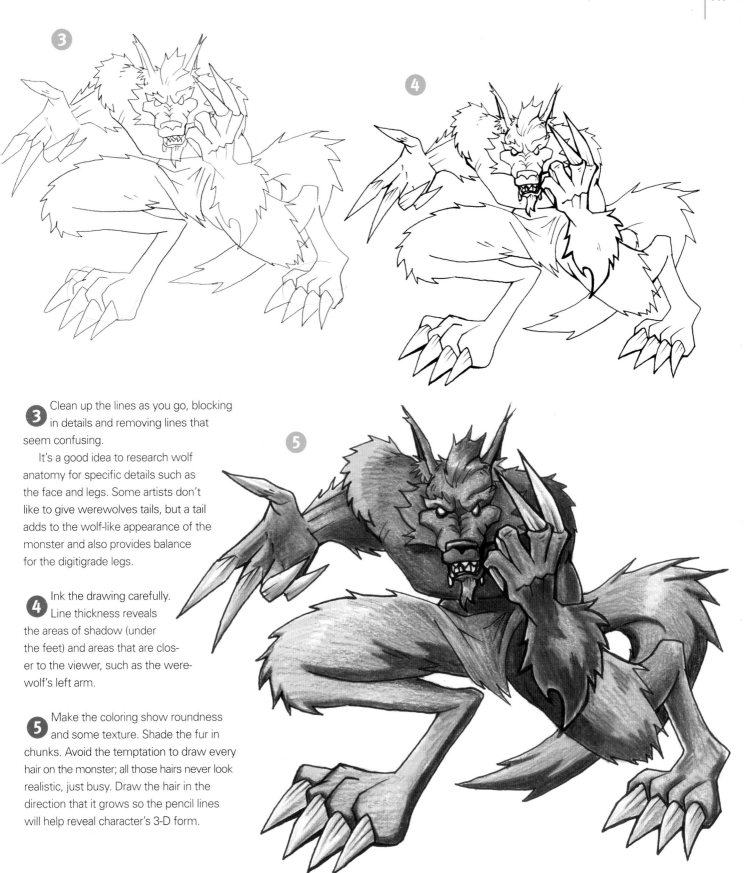

3 Clean up the lines as you go, blocking in details and removing lines that seem confusing.

It's a good idea to research wolf anatomy for specific details such as the face and legs. Some artists don't like to give werewolves tails, but a tail adds to the wolf-like appearance of the monster and also provides balance for the digitigrade legs.

4 Ink the drawing carefully. Line thickness reveals the areas of shadow (under the feet) and areas that are closer to the viewer, such as the werewolf's left arm.

5 Make the coloring show roundness and some texture. Shade the fur in chunks. Avoid the temptation to draw every hair on the monster; all those hairs never look realistic, just busy. Draw the hair in the direction that it grows so the pencil lines will help reveal character's 3-D form.

sea
Creature

*T*hat's no mermaid sitting on that rock; it's a sea creature who is better suited for life in the depths of the ocean than skulking around on dry land. She has fins for agile movement underwater, gills for extracting the oxygen out of water and webbed feet and hands for efficient swimming.

1 Make the legs appear foreshortened as they move forward and backward in imaginary space. Make the tail a natural extension from the initial action line that relates to the spine of the sea creature.

2 Block in details such as the fins and underbelly scales. Make the fingers and toes of the sea creature webbed to allow for enhanced swimming. Make the gills on the side of the neck just visible at this stage.

Earth's Final Frontier

The sea is mostly undiscovered territory, full of uncataloged life forms and mysterious locations. Water covers over 80 percent of the earth's surface, but less than 5 percent of the ocean has been mapped. What people do not know or understand, they fear. Horrors from the sea include giant squids, ship-sinking sea serpents and giant sharks. American horror writer H.P. Lovecraft even placed his most horrifying monster, the dreaded Cthulu, sleeping deep under the sea.

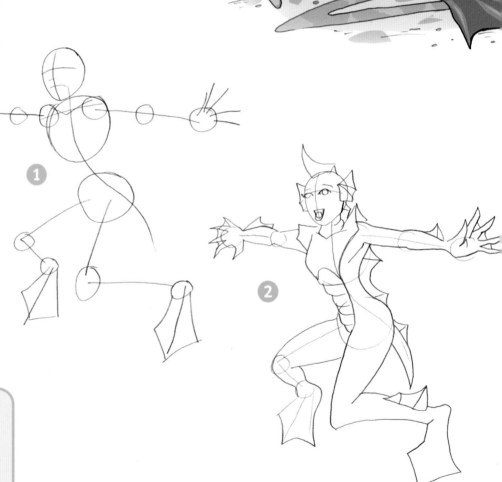

Forget the Rules

The pose for this drawing shows a figure swimming underwater, so the usual rules of weight and stance are not applicable.

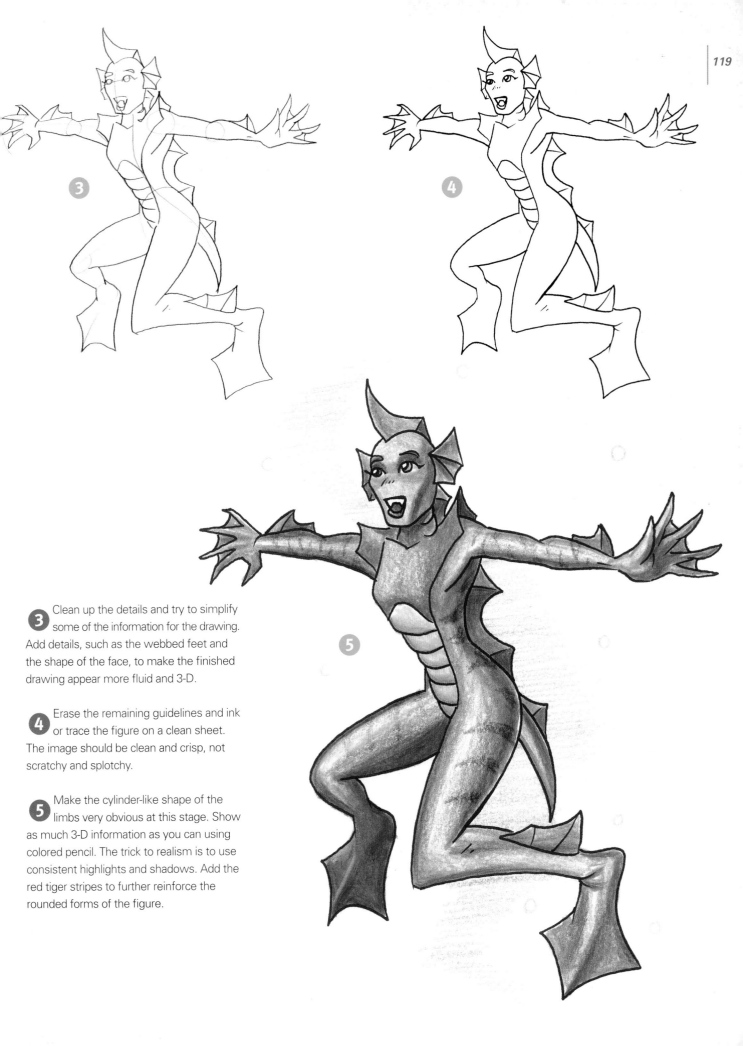

3 Clean up the details and try to simplify some of the information for the drawing. Add details, such as the webbed feet and the shape of the face, to make the finished drawing appear more fluid and 3-D.

4 Erase the remaining guidelines and ink or trace the figure on a clean sheet. The image should be clean and crisp, not scratchy and splotchy.

5 Make the cylinder-like shape of the limbs very obvious at this stage. Show as much 3-D information as you can using colored pencil. The trick to realism is to use consistent highlights and shadows. Add the red tiger stripes to further reinforce the rounded forms of the figure.

Ghost

Ghosts can appear in many forms. This ghost is an apparition of ectoplasmic mist and energy. Japanese ghosts do not have obvious legs, but appear to be floating on air. The horrifying appearance of the skull and the glowing red eyes add to the sense of terror.

The skull and shock of hair are the only indications that this creature was once humanoid.

1 This image is fairly simple; you want to totally block it in at this stage. The trickiest thing to do is to make the tentacles of mist or ectoplasm appear fluid and mobile.

2 Develop the details such as the skull and the wispy tendrils. Use dark lines to reveal areas of shadow and mass. The shapes of the tendrils are reinforced with lines that help describe the forms of limbs.

3 Shade and color the ghost simply, being sure to echo the lines that describe the form. Make the hair look as if it were glowing, like some kind of exploding halo. Make the eyes aflame with a mysterious red glow.

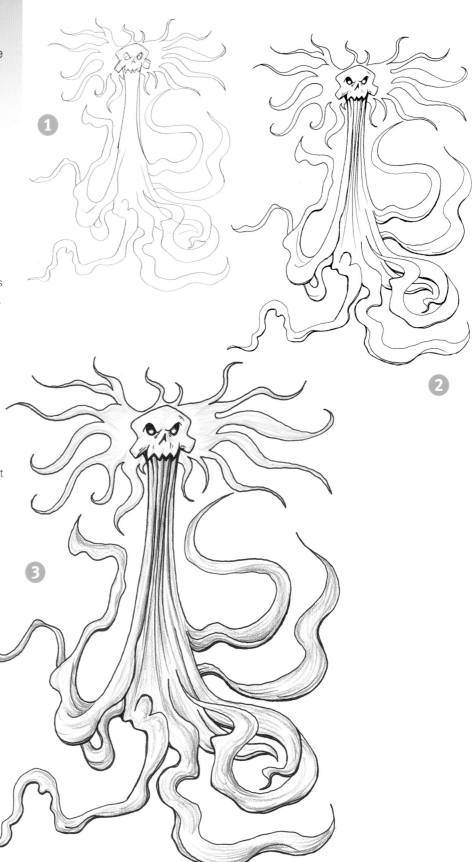

Zombie

What can be more terrifying than the shambling dead, raised from the grave and seeking the destruction of the living? The mindlessness and seemingly indestructible nature of a zombie makes it scary, but the prospect of being confronted by thousands of these things is truly horrifying.

Draw zombies with human proportions, but twist and contort them in unnatural ways to create something that seems inhuman.

1 Block in the figure as usual, but make him twisted and contorted. The legs look barely able to support the figure and the head is way off the center of gravity, giving the zombie the appearance of falling or poor balance.

2 Ink the drawing, adding details such as torn clothing and a shriveled anatomy. The skeletal structure of the zombie should be evident; it will require some research on anatomy to make it look convincing.

3 Choose unusual skin colors to make the skin look unhealthy. This skin is a lovely mix of blue, aqua green and some purple. Add some green goo dripping from the mouth—you know, that wonderful mystery fluid that zombies seem to exude. Keep things simple. Know which direction your light is coming from and try to make all of your highlights and shadows consistent with it.

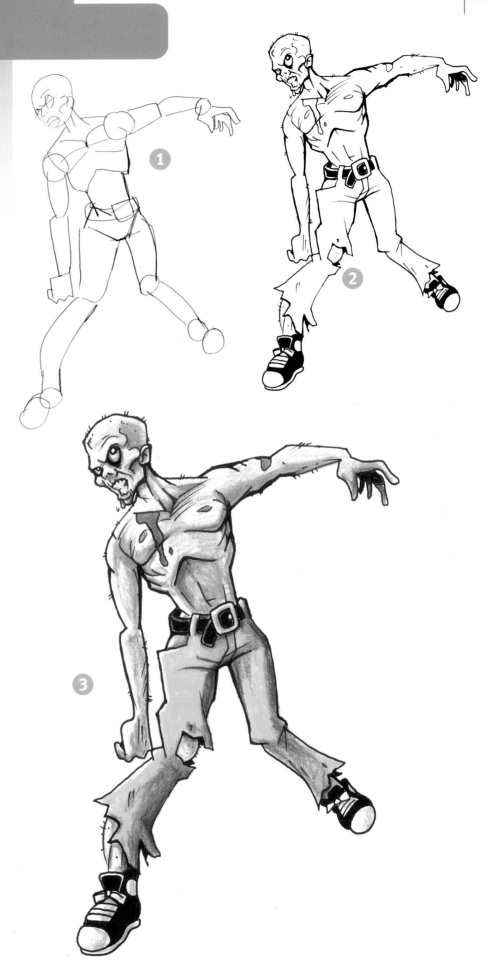

Wizard

The wizard is often depicted in literature as someone who is able to cast spells, employing superhuman endurance and willpower.

Overall, this wizard is a bold contrast and fun alternative to the shambling horrors of most supernatural manga. That's why we like her so much. This wizard's eyes glow red when she weaves her magic.

Messing with the forces of nature can have adverse effects on the human mind, turning a well-meaning sorcerer into a fireball-hurling monster bent on destroying the world. Absolute power can corrupt absolutely!

1 Start with the standard structure. Make sure the lines are light and loose. While blocking in the book, keep in mind how large her forearm should be behind it. The open hand will be casting the spell. She doesn't want all that powerful magic zipping around too close to her body, so she is holding her arm as far away as she can.

2 Add details such as the toes, jewelry and clothing. Note the areas of creases and folds on the pants as well as the decorative flares and the fancy disco belt. Add the tooth necklace to give her a bit of character.

3 Keep the colors bright and fun. The "magic" symbols are just fancy scribbles that have been outlined. The writing in the book was done with a sharp colored pencil. I wonder what spell she is casting?

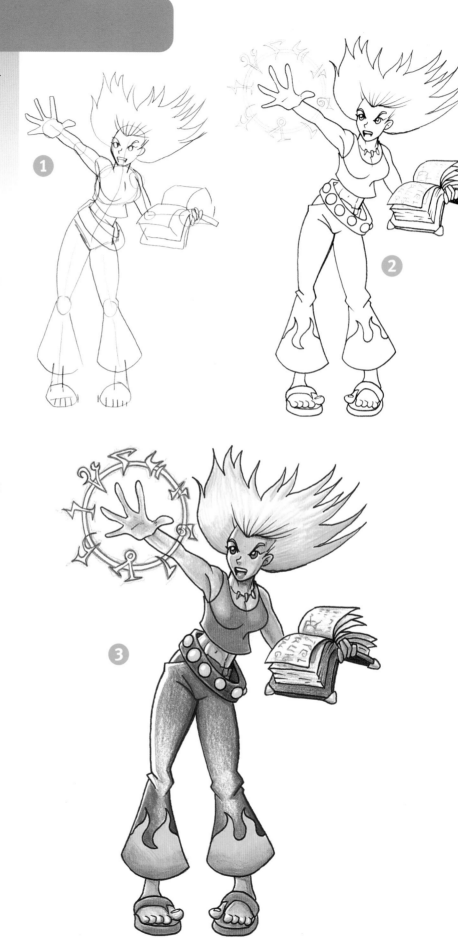

immortal Warrior

*T*he immortal warrior has attained eternal life and uses his skills and powers to ensure his continued existence or to destroy his enemies. This Egyptian-themed immortal is wrapped in mummy bandages and wears an ankh, the symbol of everlasting life. He also wields two nasty-looking ancient Egyptian swords, or khopesh.

1 Draw the character in a full run, crouched low. He is brandishing two khopesh weapons. The swinging ankh helps indicate the speed of his run. He is leaning forward, so you will have to foreshorten the torso. The head will seem large because it is closer to the viewer.

2 Add details such as the flowing wrappings and the wild hair. (For some reason, when I draw mummies I draw them with wild hair, even though I know that the pharaohs were shaved bald.) Add a highlight on the hair to keep the head from looking too flat. Notice how the thicker lines help make objects and areas of the figure stand out from the background and appear to come forward.

3 The final shading with colored pencil will create the impression of a character existing as a 3-D form. Keep the shading simple, but never just use one color for one area. Use at least two or three colors to get the color you are looking for. Draw the wrappings with yellow, beige and reddish brown.

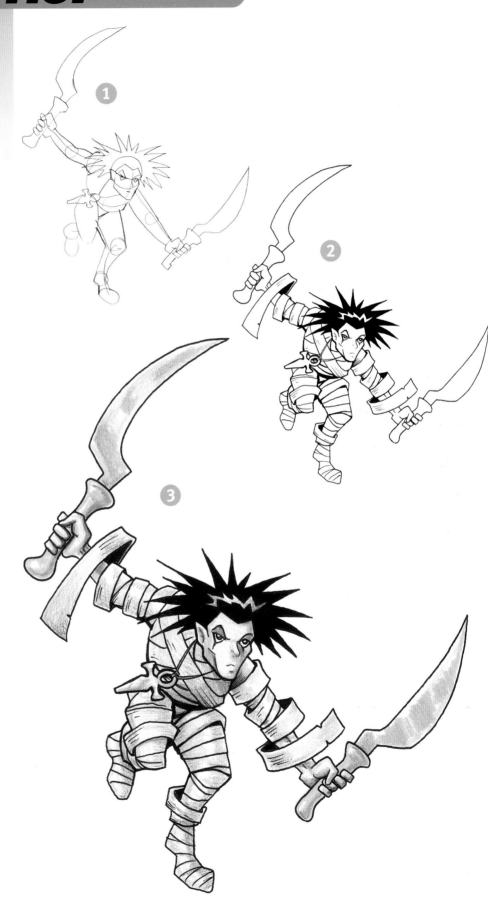

mixing Genres

Part of the fun of making your own manga is telling the kind of stories you like.

Mix Genres

When you mix genres, you create something new from elements with which readers are already familiar. Some of the combinations are easier to imagine than others. Alien/daikaiju combinations have been seen in movies like *The Mysterians* (1957) and *Godzilla vs. Monster Zero* (1965), television shows like *Ultraman* (1966) and anime such as *Science Ninja Team Gatchaman* (1972).

Mixing pet monsters with high fantasy resulted in a 1999 videogame and anime franchise called Monster Rancher.

Expand Your Ideas

It must be stated again that manga is not a genre; it is a medium of expression. Not all manga have schoolgirl monsterhunters, just like all American comics don't have spandex-clad superheroes. The possibilities for stories and expression have been explored more widely in manga than in comics. One of the best side effects of the popularity of anime and manga has been how North American comics have changed in response. North American comics are only now beginning to expand their range of ideas.

Create Better Stories

It's also important to understand that once you know the rules and archetypes of a given genre, you can then avoid stereotypical storytelling by breaking the rules once in a while. If the story of the brave knight who saves the day by rescuing the princess has become old, try having the princess save the knight. Or better yet, have the dragon be the hero, and present the mean knight and stuck-up princess as the enemies.

Write and draw the stories you want to read. You'll be surprised how creative you really are!

further Reading and Reference

Books

Addiss, Stephen, ed. *Japanese Ghosts and Demons*. New York: George Braziller, Inc., 1985.

Cotterell, Arthur. *Dictionary of World Mythology*. New York: Oxford University Press, 1990.

Cotterell, Arthur. *Encyclopedia of Ancient Civilizations*. New York: Mayflower Books, 1980.

Cotterell, Arthur. *Mythology: An Encyclopedia of Gods and Legends From Ancient Greece and Rome, the Celts and the Norselands*. London: Southwater, 2000.

Levi, Antonia. *Samurai From Outer Space*. Chicago: Open Court, 1996.

Piggott, Julie. *Japanese Mythology*. New York: Peter Bedrick Books, 1991.

Schodt, Frederik L. *Manga! Manga! The World of Japanese Comics*. Tokyo; New York: Kodansha International, 1983.

Online Articles

Kinsella, Sharon. "Cuties in Japan," Women, Media and Consumption, ed. Lise Skov and Brian Moeran, <www.kinsellaresearch.com/Cuties.html>, posted 1995.

Screech, Tim. "Japanese Ghosts," Mangajin 40, <www.mangajin.com/mangajin/samplemj/ghosts/ghosts.htm>, posted 1998 .

Websites

Areopagus
www.areopagus.net/index.html
A good reference for Greek mythology.

Destroy All Monsters
www.destroy-all-monsters.com
A good reference for Asian-American pop culture.

Japan Hero
www.japanhero.com
This site's Monster Index is a catalog of monsters from sentai and kaiju movies and television shows. It includes illustrations but not much information.

Stomp Tokyo
www.stomptokyo.com/index.htm
This site reviews monster movies and includes lots of information on daikaiju films.

Virtual Illusions
http://quasisemi.com/myth
This page describes a few of the eight million kami (spirits) in Japanese mythology.

if you're going to draw
—Draw with IMPACT!